IMAGES
of America

AROUND BETHANY

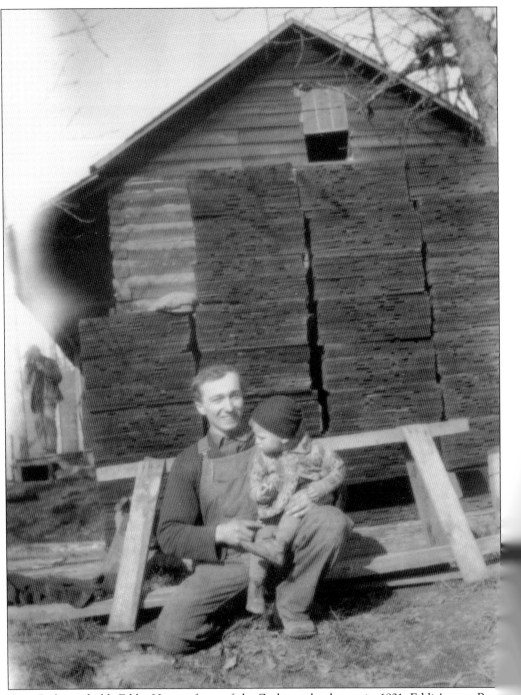

Otto Zurbrugg holds Eddie Hirt in front of the Zurbrugg log house in 1921. Eddie's aunt Ros
Barker lived nearby. When his parents died, Eddie was adopted by Rose and Kendal Barker, ar
his name was changed to Eddie Barker. (Courtesy Sandy Baker.)

ON THE COVER: In this 1920s photograph, Lily Croeni sits in her garden with a stack of pumpki
near Bethany, north of Cornell Road. (Courtesy Grace Jenne.)

IMAGES
of America

AROUND BETHANY

Donald R. Nelson

ARCADIA
PUBLISHING

Published by Arcadia Publishing
Charleston, South Carolina

Printed in the United States of America

Library of Congress Control Number: 2017957078

For all general information, please contact Arcadia Publishing:
Telephone 843-853-2070
Fax 843-853-0044
E-mail sales@arcadiapublishing.com
For customer service and orders:
Toll-Free 1-888-313-2665

Visit us on the Internet at www.arcadiapublishing.com

This book is dedicated to my wife, Patty, who has been my sounding board and editor of the original manuscript. She has spent countless hours helping on this project.

CONTENTS

ACKNOWLEDGMENTS

Special thanks go to curator Liza Schade and the volunteers at the Washington County Museum, who have made my search for historical material informative and enjoyable; all photographs provided by them are indicated by WCM.

A thank-you goes to the descendants of early day families who have shared their stories and provided historical insights and photographs of their ancestors; those who provided images used in the book are acknowledged in the captions.

A special shout-out goes to Alan Toelle, who sent me his historical writings about his ancestors along with many photographs. Thanks also go to Gary Sehorn, Graf family historian, who has shared his writings with me over the years. Col. Mike Howard was also a valuable source of information about Bethany Baptist Church.

Publications consulted include *School Days* by Gerald H. Varner; Samuel E. Graf's autobiography; *The Grafs of Bethany* by Gary Sehorn; *Our place in Helvetia* by Donald N. Miller; and *The Bethany Community: As It Was And Is Today* and *Bethany: A Community in Transition*, both by Donald R. Nelson. The *Oregonian, Oregon Journal, Hillsboro Argus*, and *Hillsboro Independent* newspapers were referenced. Historical books about Bethany Bible, Bethany Baptist, and Bethany Presbyterian Churches and Trinity Fellowship Church were consulted, as were church office staffs, who were very helpful.

INTRODUCTION

I became interested in Bethany in 1975 after my wife, Patty, and I married. We lived on NW Springville Road, and I began photographing farms in the area. We attended Bethany Baptist Church and became acquainted with descendants of early settlers. Since then, a web of connections has introduced me to many others around the Bethany area. I have talked to dozens of relatives of the early people of the area. They have given me access to their photographs and family memorabilia and have enabled me to understand the early days and changes that have been made over the years.

The area around Bethany saw increased population in the 1870s, with immigrants from Switzerland and other European countries. Some came for religious freedom or to escape military conscription. Many corresponded with friends who had already been in the Cedar Mill–Bethany area.

The earliest Swiss and German settlers in Bethany and surrounding land in the 1870s worked hard to clear trees so they could farm. Most built log houses, as few could afford lumber. Barn raisings, where neighbors helped neighbors, happened at times. Farmers would help each other out during threshing time, and threshing crews went about their work going from farm to farm. Originally, the crews had steam tractors powering their equipment. It was hard to make a living from farming. Some had to rent several fields.

Many had their earliest church meetings in the homes of members before a house of worship could be built. Schooling was important to these pioneers.

Horses were used to get places. Sometimes, riders traveled individually on horseback or with the horse attached to the family wagon to go to church. They also took their produce and dairy products to sell in Portland. When the automobile age came, the farmers that could afford them bought vehicles in the 1910s.

As things continued to progress, telephone lines and electricity reached farms. Fewer farm children were interested in farming and sought an education and professional jobs.

The development of Sunset highway (US Highway 26) in 1946 split farmland into smaller lots. Former neighbors who lived near each other had to take a circuitous route through the two-lane highway to visit each other. In 1964, an extra lane was added to the highway in each direction, bringing an end to property owners' driveways connecting onto the highway. Overpasses were built where the side roads originally had stop signs to cross into and through the highway. An overpass was built at NW 185th Avenue in the 1970s because of the hazards of school buses crossing the highway after stopping at the edge of Sunset Highway.

The Bethany community has undergone so much change in recent years due to development. Many from old families, who do not live in the area any longer, do not recognize the area when they come back to visit. With the first wave of development in the late 1980s, many of the old farmhouses were retained but surrounding them there was modern architecture. With the passing years, the houses go down and even the wetlands of former farm property have been redirected to maximize buildable sites. Old trees have also been removed.

The Urban Growth Boundary has been expanded in recent years. With more residents in individual dwellings and apartment houses, automobile traffic has increased dramatically. New schools are also being built. Bethany Village development brought houses, apartments, a senior living facility, a Quality Food Center (QFC) store, Walgreens, and retail stores.

Today, the sale of acreage has happened in part because of rising taxes on the land.

More land may be developed in the near future as community meetings with county commissioners and landowners consider new proposed developments.

One

FROM EUROPE TO BETHANY

Samuel Siegenthaler was a wealthy Swiss farmer who organized a party of emigrants to the United States in 1876. Upon arrival in the Bethany area, Siegenthaler purchased large portions of land for his friends from his homeland with the stipulation he was to be paid back so he would be able to finance passage for more people from the old country. (Author's painting.)

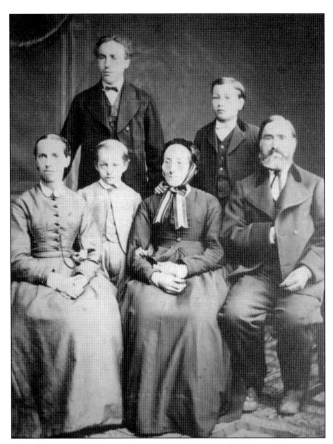

This photograph of the Johann Graf family dates to around 1875. Graf was a farmer, colporteur for the British Bible Society, and later a circuit missionary. He led several home churches. Graf desired a place to preach and worship freely and a place where his family would have greater economic opportunities. Their prayers were answered when a fellow member of their free church, Samuel Siegenthaler, offered them passage to the United States if Graf found a buyer for one of his farms. When this was accomplished, more of their friends wanted to go to America also. (Courtesy Graf family.)

Christian Luethe poses with his parents in front of their home in Switzerland in the early 1870s. He married Anna Barbara in 1874. (Courtesy Jennifer Saks.)

Near the middle top of this photograph is where the Zurbrugg family lived at Ladholz Canyon in Frutigen, Switzerland. Chris and Abe Zurbrugg came to America to have a chance at a better life in the mid-1880s. They lived in Ohio for a couple of years before coming to Oregon. Their sisters Sophie Josse, Susanna Hefty and Katherine Shaw and brother Gottlieb also emigrated from Switzerland. (Courtesy Gene and Launa Zurbrugg.)

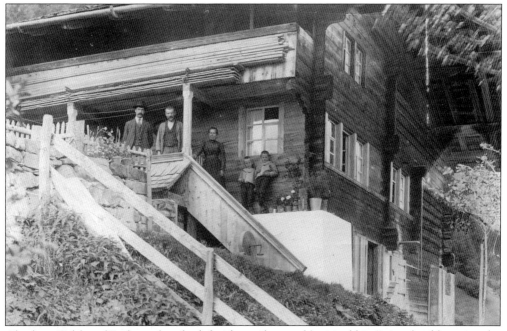

Abraham Zahler of Bethany (on the left side on the porch) visited his Switzerland home in the 1910s. He came to America around 1891. (Courtesy Gene and Launa Zurbrugg.)

In March 1876, the Samuel Siegenthaler Swiss migration group from Switzerland traveled by train from Burgdorf, Switzerland, to board the steamship *La France* at Le Havre, France. Their ship landed in Philadelphia. This photograph of the port of Le Havre dates to the late 1870s or early 1880s. (Author's collection.)

The Centennial Exposition was held in Philadelphia, Pennsylvania, in 1876. Passengers on the ship that the Swiss Siegenthaler group was on disembarked in Philadelphia as a variety of materials for the centennial were on the steamship that brought them to America. (Author's collection.)

The Siegenthaler group came west on an immigrant train. Their railcar, which was very primitive, was coupled to a freight train. Upon reaching Sacramento, California, they took a boat to San Francisco. Four days later, they boarded a steamboat bound for Portland. This illustration of a train and steamboat is from an 1876 *Portland City Directory*. (Author's collection.)

The Johann Graf family was part of Siegenthaler's group initially. They stopped to visit their daughter Elise-Martha and her husband, John Bachman, in Cincinnati, Ohio, and left their young son William with her to go to school for a few years. The Grafs went on to Oregon, as the Siegenthaler group had done previously. In Portland, the Grafs ended up at a rat-infested hostelry, the Globe Hotel. The next day, they went west by horse and wagon to the Cedar Mill area, where their Swiss friend Peter Senften lived. This advertisement of the hotel dates to the mid-1870s. (Author's collection.)

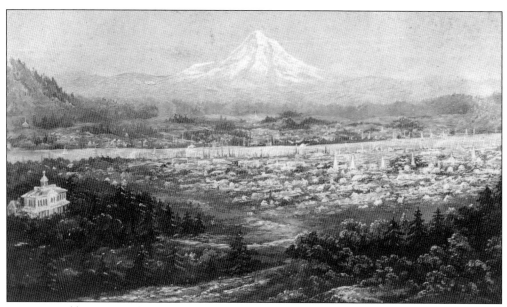

Mount Hood looms over the farmland of east Portland in this late-1870s photograph of a primitive painting of Portland. On the lower-left side, Good Samaritan Hospital in northwest Portland appears to be on a precipice overlooking downtown Portland. (Author's collection.)

Portland SW First Avenue in the 1870s was the home of many businesses. The storefront, with the book on a cast-iron pedestal, is for J.K. Gill, which was a book and stationery company that began in Salem, Oregon, in the 1860s. It was a prominent business in Portland for decades beginning in 1871. (Author's collection.)

Two

CHURCHES

This is the cover of Rosette Siegenthaler's German hymnbook *Psalter and Harfe-Lieder und Melodien fur Schul, Haus and gottesdienstlichen Gegrauch.* The title translation is *Psalter and harp songs and melodies for school, house and worship.* Rosette was the daughter of Samuel Siegenthaler; she married Alfred Guerber, who worked for Siegenthaler. Alfred and Rosette bought farmland in Helvetia in the early 1880s. (Author's collection.)

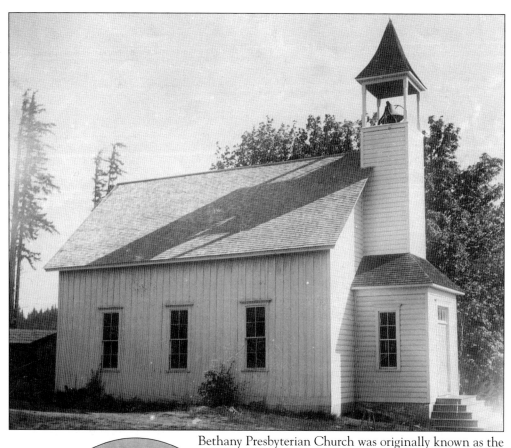

Bethany Presbyterian Church was originally known as the First German Presbyterian Church of Bethany, Oregon. It was organized in the home of Christian Linder in 1873. Rev. Henry Gaus was the minister. The next year, their building was erected on two-acres of land donated by charter member Jacob Brugger. A cemetery was also included on the property. A bell tower and addition were built in 1894. The image is from around 1900. (Courtesy Bethany Presbyterian Church.)

Henry Gaus served Bethany Presbyterian Church from its organization in 1873 until his death in 1884. This photograph dates to the late 1870s. (Courtesy Bethany Presbyterian Church.)

In 1905, Bethany Presbyterian Church relocated to a new building, at the corner of NW Springville and Kaiser Roads, on property Jacob Brugger donated. This view is from around 1923. The structure was used for worship services until a new church was built in 1958. The old structure was then used for Sunday school purposes. Its steeple blew down during the October 12, 1962, storm and was never rebuilt. After a 1966 fire destroyed the upper part of the church, the basement of the building was enclosed and used for several years, with the structure later to be torn down. (Author's collection.) Rev. Henry Dickman was the minister of the Bethany Presbyterian Church beginning in 1925 and faithfully continued serving the congregation until poor health lead to his retirement in 1950. He then became pastor emeritus of the church. This photograph of Dickman and his family dates to the mid-1930s. Pictured from left to right are (first row) Ruth, Paul, and Miriam; (second row) Margaret (mother), Henry (father), Margaret, and Henry. (Courtesy Ray and Beverly Kestek.)

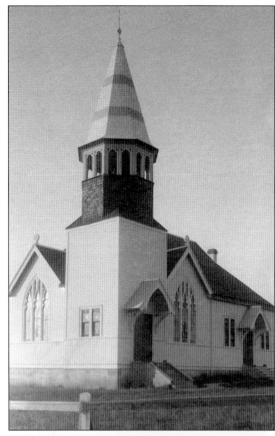

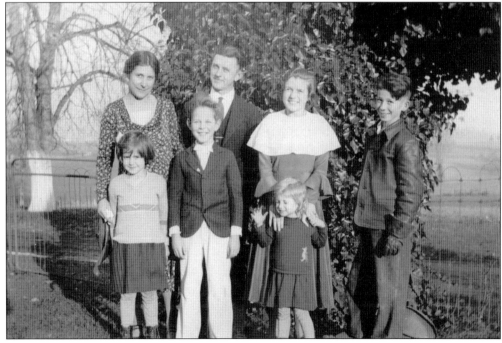

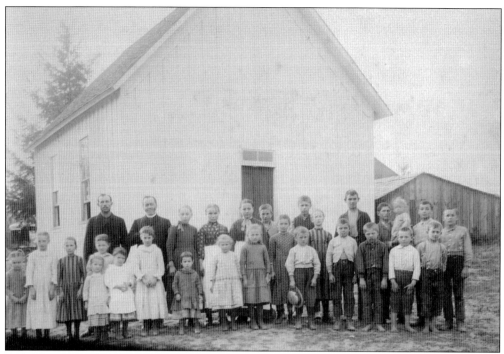

Bethany Baptist Church was organized in 1879 and was originally named the First German Church of Baptized Believing Christians of Bethany. Its nucleus was made up of many Swiss immigrants who came to the area in 1876. The first building was erected in 1881. The c. 1887 photograph includes pastor John Croeni and his children. Also included are children from the Gerber family. (Courtesy Bethany Baptist Church.)

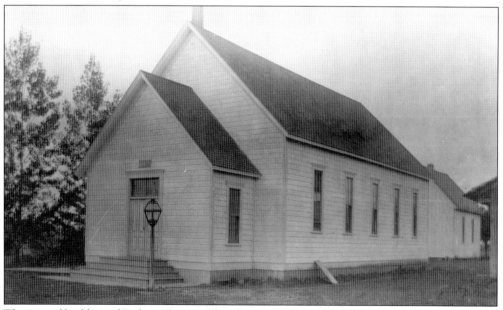

The second building of Bethany Baptist Church was erected in 1890. The first building was moved back to allow room for the new, larger church. The 1881 building stands preserved on the church campus today. This photograph is from about 1900. (Author's collection.)

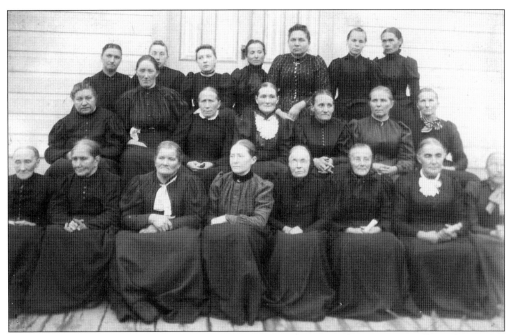

This c. 1900s photograph shows the Women's Missionary Society, known originally as the Frauen Verein. Its membership included women from the Graf, Eggiman, Stalder, Kargel, and Gerber families. (Author's collection.)

Missionaries to Cameroon, in West Africa, Emil Suevern and his wife, Anna Suevern, were on furlough and staying in the parsonage at the Bethany Baptist Church in the late 1890s. Both of their first spouses died of dengue fever in the 1890s. Emil was asked to stay on as pastor. Anna organized the Women's Missionary Society in 1899. They were called back to Cameroon in 1900. Anna also died of dengue fever in 1901. (Author's collection.)

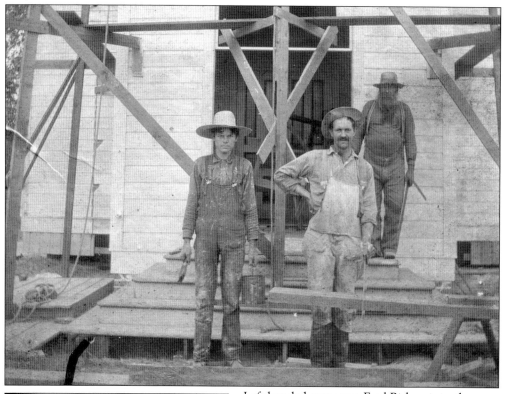

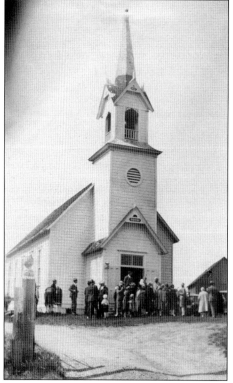

Left-handed carpenter Fred Bishop is in the center of this c. 1900 construction photograph of the bell tower at Bethany Baptist Church's second building. Fred, born in Helvetia, was the son of Joseph Bishop. On his left is Ernest Schaer, a son of early Bethany carpenter Friedrich Schaer. The man in the right background is Helvetia carpenter Peter Welty, whom Bishop worked with building barns in Cedar Mill, Bethany, and Helvetia. They also built houses and churches. (Author's collection.)

The congregation of Bethany Baptist Church is gathered around the front of the building in this c. 1927 photograph. That year, the church was lifted up and moved with the help of a horse-powered stump puller and logs that the building rolled on. Church services were held in the relocated building until the basement was dug and construction of the new building was completed. (Author's collection.)

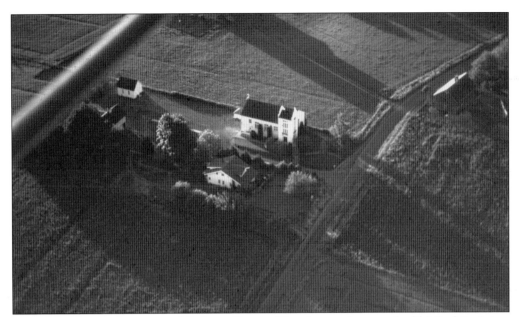

This late-1940s airplane view of Bethany Baptist Church was photographed by Rod Eggiman, a member of the church. In the center of the image is the third sanctuary, built in 1928. In the left background is the original chapel of 1881; the barn below the chapel was later remodeled for Sunday school use. The house, below the church, is the parsonage that was built in 1923 and remains in use. Today, the former fields around the church campus are occupied by residential housing. (Rod Eggiman photo, courtesy Tony and Linda Smith.)

In this c. 1940 photograph, Otto Zurbrugg, with baton in hand, directs combined choirs from Bethany-area churches for one of the events that were known as Sunday School Conventions. They were held at Bethany Baptist Church and included choir members from the Bethany Baptist Church as well as Bethany Presbyterian and Bethany Methodist. The event was basically a church service that included prayer, a sermon, and an offering that was taken in support of missionaries. (Courtesy Gene and Launa Zurbrugg.)

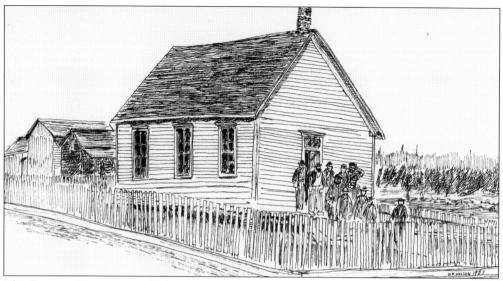

The German Congregational Church of Cedar Mills was organized in 1887. Within a year or two, a house of worship was built. Many of the members had been part of the 1876 Swiss migration led by prominent farmer Samuel Siegenthaler Sr. Johann Graf, their pastor, had been the head of this Swiss colony, located in the Bethany and Cedar Mill area, that met in the member's homes for church services. Many of this group became members of Bethany Baptist Church; others stayed with Siegenthaler and Graf. They met in homes for many years before building their own house of worship. (Author's drawing.)

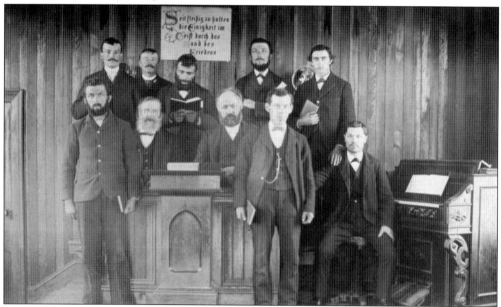

Men of the German Congregational Church of Cedar Mills gather around the church pulpit. This late-1880s photo includes many farmers from the Bethany and Cedar Mill areas. They are, from left to right, (first row) John Schaer, Peter Senften (Swiss immigrant from the early 1870s), Samuel Siegenthaler Sr., John Hofer, and early carpenter Friedrich Schaer; (second row) Christian Schindler (Siegenthaler's nephew), Henry Stoffers, Gottlieb Conrad, Christian Zurcher, and William Graf. (Courtesy Siegenthaler descendants.)

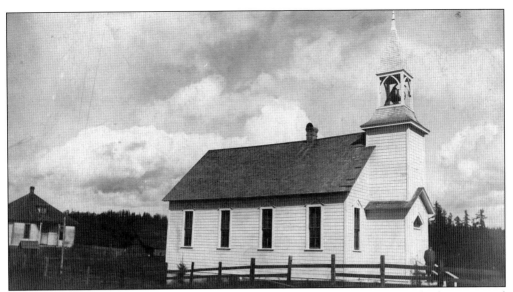

At NW Germantown Road near NW 185th Avenue, the Phillips German Methodist Episcopal Church was built in 1895 or 1896 with the guidance and carpentry skills of the Reverend John W. Beckley and others. Later, it was named Bethany Methodist Church. As in other Bethany-area churches, the spoken language was German. In 1930, all services were held in English after the church joined the English Methodist Conference. In the mid-1960s, the church dropped its Methodist affiliation and became Bethany Community Church. Today, it continues under the name Bethany Bible Church. (Courtesy Dale Burger.)

When Rev. John Beckley was building his church, his family first lived in a tent near the church. Later, an unidentified bachelor gave up his house near the church to the Beckleys and lived in a shack nearby. An inscription on the c. 1895 photograph's border was written by Beckley or a family member; it reads "Bethany where we lived." (Courtesy Hulda Beckley Fitzsimons.)

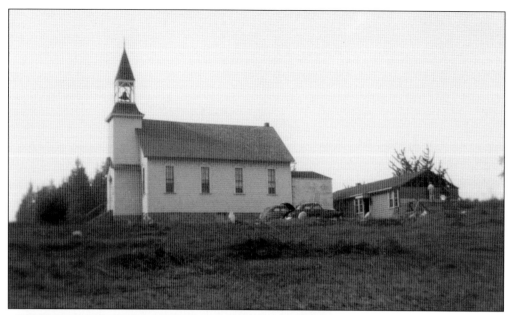

In 1951, Bethany Methodist Church had moved in an old defense home (right of the church) brought from Portland to repurpose into Sunday school use. A basement had also been added for Sunday school use. (Courtesy Ron and Marvin Stoller.)

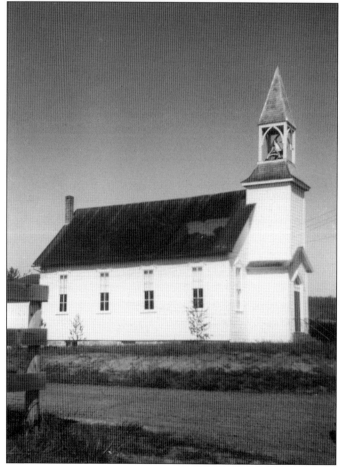

In 1971, the Bethany Bible Church looked the same as it did in the photograph from 1900. (Courtesy Reichen family.)

Three

SCHOOLS

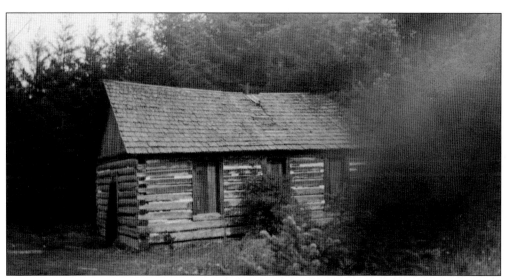

The first Rock Creek School was built of logs and was first used in 1878. It stood south of NW Germantown Road and was west of NW 185th Avenue. It was utilized until a school was established in Bethany in 1887. A new Rock Creek School was later built on NW Phillips Road. The log building, seen in this c. 1925 photograph, no longer exists. (Courtesy Clark and Betty Dysle.)

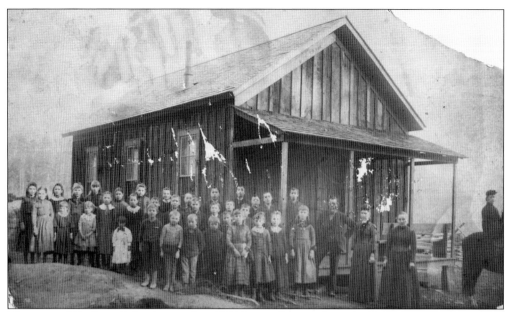

The original Bethany School opened in 1887. Its pupils came from the Stalder, Graf, Joss, Gerber, Dysle, and other local families. The photograph is from 1890. By the mid-1890s, the structure was enlarged at its north end. The school was located on Caspar Baumann's property, north of Springville Road, near today's Portland Community Colleges Rock Creek Campus and the western edge of the Arbor Oaks housing development. (Author's collection.)

Samuel H. Graf photographed his classmates seen in this c. 1900 image. The school is in the right background. This school was closed and sold at auction to a farmer. Graf was a prolific amateur photographer of farms, families, and others in the Bethany area. (Author's collection.)

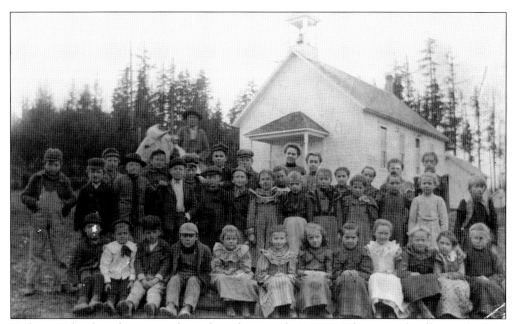

Bethany School students pose for a class photograph in 1902. The new schoolhouse, built in 1900, is in the right background. The teacher can be seen in front of the school's porch. Hedwig Dysle, future wife of Ernest Schaer, is to her right. (Author's collection.)

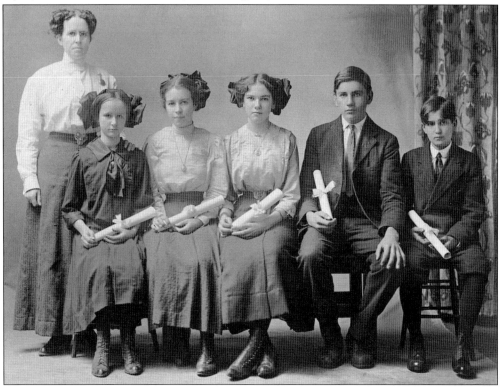

This is the Bethany School's eighth-grade graduating class of 1906. The girl in the middle of the front row is Anna Graf. (Author's collection.)

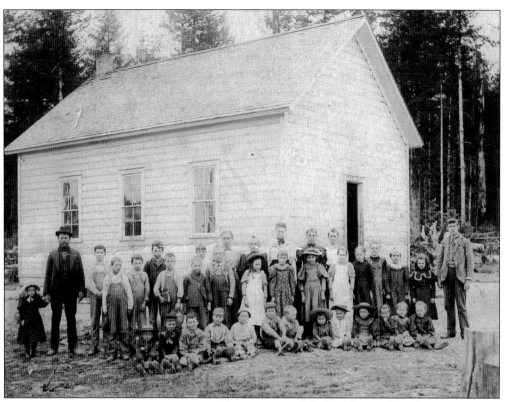

This is a view of the building and students of School District No. 81, known as McKinley School. Farmer John Meier is second from the left. The school was built in 1889 by Albert and Ernest Keehn. Harry Hansen was one of the young students. The photograph dates to the mid-1890s. (Courtesy John Hansen.)

PUPILS

Arnold Berger	Emma Berger
Flora Berger	
Lena Berger	Anna Donovan
John Donovan	
Richard Donovan	Eleanor Hamel
Maud Hamel	
Harry Hansen	Jesse Hansen
Emma Hellberg	
Metta Hellberg	Clara Mead
Frances Mead	
Janie Mead	May Mead
Freda Stucki	
Rosa Stucki	Ellen Zuercher
Fred Berger	
Alma Foege	Carl Foege
Clara Foege	
Albert Meier	Johnny Meier
Ida Meier	
Emma Keehn	Helen Trachsel
Fred Trachsel	
Nellie Johnson	Hulda Stucki
Mary Stucki	
Bertha Stucki	Herman Zuercher
Andrew Zuercher	
Nelse Johnson	Carl Trachsel
Robert Trachsel	
Mary Trachsel	Emma Trachsel
Lillie Trachsel	
Mary Trachsel	Amiel Trachsel
Jack Trachsel	
Firmin Langue	Freda King
Lee Mead	
Emma Oester	Johnny Reaber
Paul Reaber	

F. A. OWEN PUB. CO., DANSVILLE, N.Y.

The McKinley School souvenir card from the 1902–1903 school year lists all the pupils of the school. It serves as a who's who of farm families of the area. (Courtesy Reichen family.)

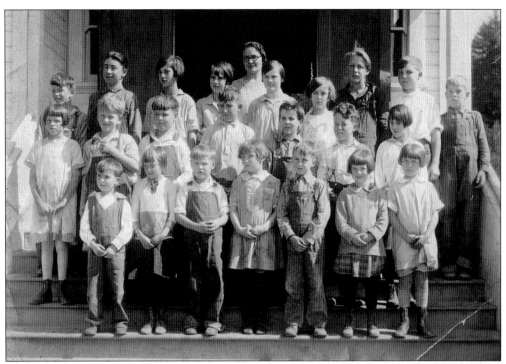

McKinley School students of 1927 stand on the steps in front of the schoolhouse that was built in 1916. (Courtesy Reichen family.)

In 1937, Lois Meier Reichen, an eighth-grade student at McKinley School, made this drawing of the pump in front of the school. (Courtesy Reichen family.)

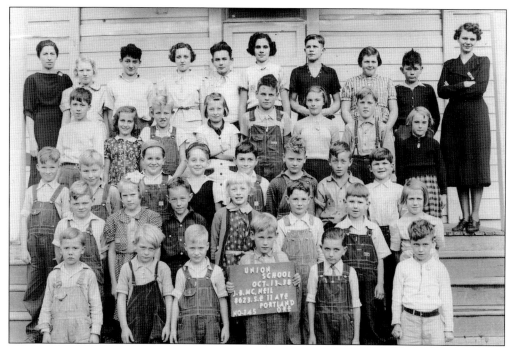

Pictured is the Union School class of 1938–1939. The school was located on NW 143rd Avenue. Among the pupils were children from the Rich, Hamel, Eggiman, Stoller, and Furrer families. This building replaced an earlier one, in the early 1900s, which was then used for other purposes. The school closed in 1948. (Courtesy Tommy Thompson.)

Directly behind the school was the Union Cemetery of Cedar Mill. The cemetery was established in the 1850s. This photograph shows the grave of Arnold Wyman, who died in 1940 at the age of 57. His parents, Peter Wyman and Anna Graber, came from Switzerland in 1876; they were married in 1878. (Author's collection.)

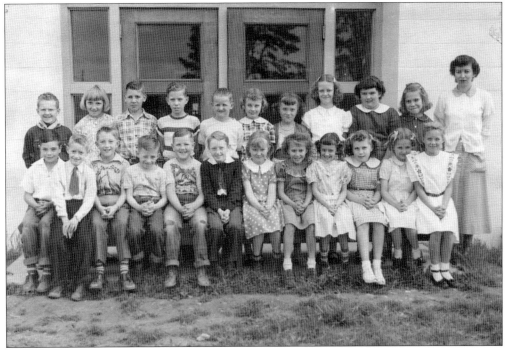

This is the third-grade class at Sunset Valley School in 1951. The school faced NW Murray Boulevard and was north of US Highway 26. (Courtesy Jean Hoffelner.)

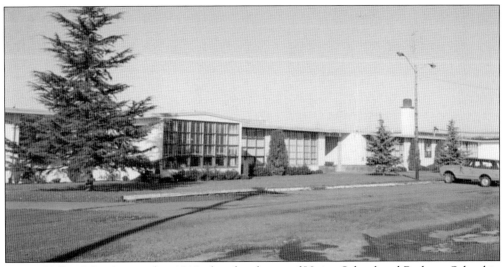

Sunset Valley School opened in 1948 after the closure of Union School and Bethany School in the late 1940s. Sunset Valley Elementary School closed around 1979. The photograph dates to 1971. The property became part of the Electro Scientific Industries campus. Today, the location is home to a Home Depot and its parking lot. (Author's collection.)

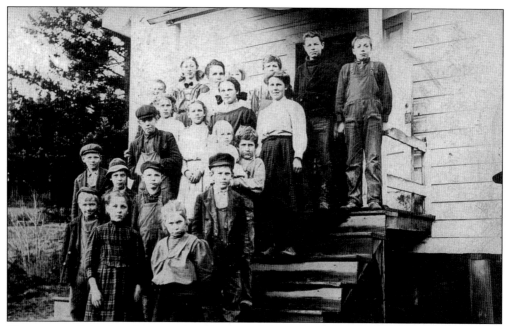

Germantown School students stand on the steps of their school in this photograph from the 1910s. It was located on NW Old Germantown Road; formerly Germantown Road, it was christened "old" when a new road was built to the north in the 1930s. The Germantown School, so named after the road it was on, was renamed Liberty School around World War I because of the war with Germany. (Courtesy Alan Toelle.)

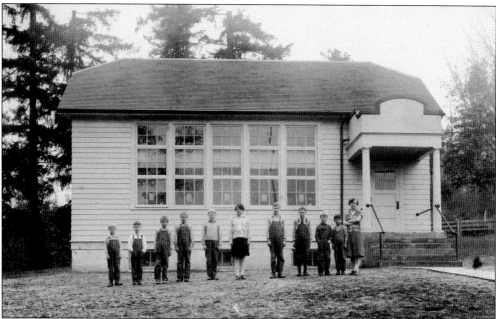

A new Liberty School building was erected over the summer of 1927. The teacher was Miss Pauley. The students are, from left to right, Ralph Toelle, Melvin McClure, George Huserik, Louis Huserik, Bob Toelle, Norma Toelle, Forest Jones, Walter Burger, Marshall Toelle, and Don Schauerman. (Courtesy Alan Toelle.)

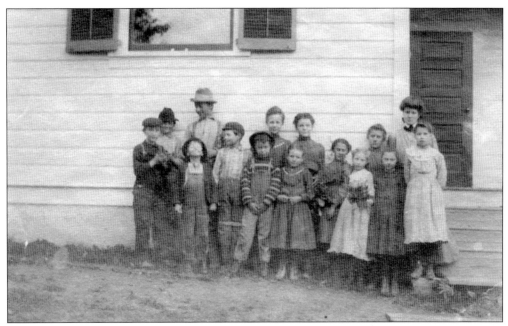

Cedarville School was on NW Skyline Boulevard. This photograph of the students and teachers dates to 1904. This school closed in 1938 when the consolidated Skyline School District absorbed Cedarville and other schools. (Courtesy Alan Toelle.)

This is the straight-A report card of first-grade student Esther Taennler, who attended Cedarville School in 1918. The school was located east of Skyline Boulevard, a short distance down the road from today's Skyline Memorial Gardens. (Courtesy Jack Enzler.)

MULTNOMAH COUNTY, OREGON

REPORT CARD

(GRADES 1 TO 3)

Cedarville School

First Grade

Year Ending *May 23* 191 8.

Pupil *Esther Taennler*

Entered *September 4* 191 7.

Month	1st	2d	3d	4th	.h	6th	7th	8th	9th	5th
Scholarship	a	a	a	a	a	a	a	a	a	a
Deportment	a	a	a	a	a	a	a	a	a	
Application	a	a	a	a	a	a	a	a		
Days Attended	18	19	20	11	14	17	18	20	20	11½
Days Absence	1	1	0	3½	0	1	2	0	0	0
Times Tardy	0	0	0	0	0	0	0	0	0	0

Esther Taennler is assigned to the *Second grade* Class

Miss Esther Baybrook Teacher

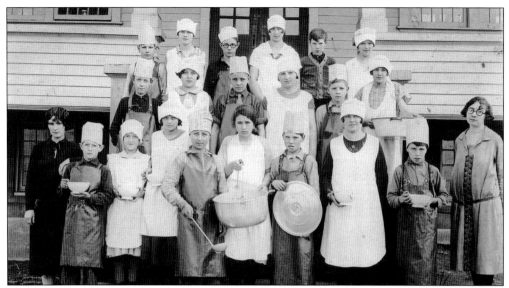

Brooks School was built in 1912 on Brooks family property at NW Skyline Boulevard. The students seen in this cooking class look ready to prepare a meal. They pose in front of their school in this 1920s-era image. (Courtesy Dale Burger.)

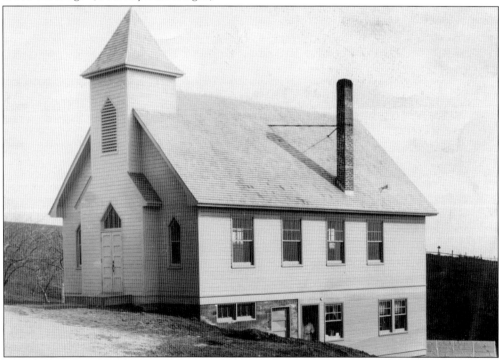

Beverly Kestek and her brother Robert "Bob" Zahler lived in the Bethany area with their parents and grandfather Abe Zahler at his farm on NW Springville Road. They rode the bus to Brooks School. Due to overcrowded conditions, in the late 1930s Beverly's fifth- and sixth-grade classes were held in the Brooks Hill Methodist Church. Mary Trachsel was her teacher. School desks replaced pews, which made seating for adults uncomfortable for church services, according to Jean Brooks Nixon. The church photograph dates to 1932. (Courtesy Dale Burger.)

Brooks School was renamed Skyline School in 1939. This photograph of the students was taken on April, 23, 1939. The old school was still being used, as were the old gymnasium and Brooks Hill Free Methodist Church for additional classrooms. Andy Huserik remembers having classes in the gymnasium and watching construction of the new school during his lunch period. The new school, built under the Works Progress Administration (WPA), was not ready for occupancy until the fall of the 1939 school year. (Courtesy Ray and Beverly Kestek.)

The 1939 graduates of Skyline School pose behind the schoolhouse. (Courtesy Jean Nixon.)

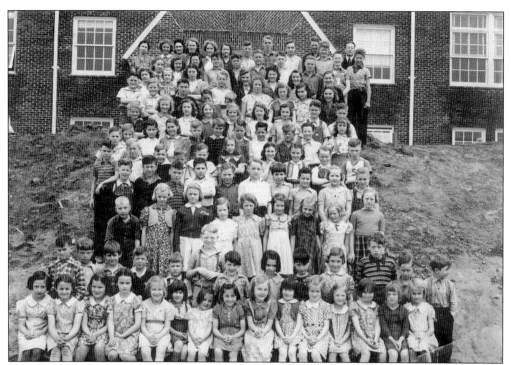

This is a group photograph from 1940 of the Skyline School students at the end of the first year that they occupied the building. Among the group are children from the Pauley, Toelle, McClure, Brooks, Huserik, and Covic families. (Courtesy Alan Toelle.)

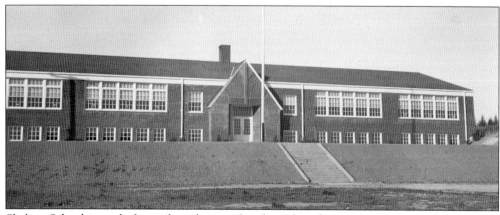

Skyline School is ready for its front lawn to be planted in this c. 1941 photograph. (Courtesy Gene and Launa Zurbrugg.)

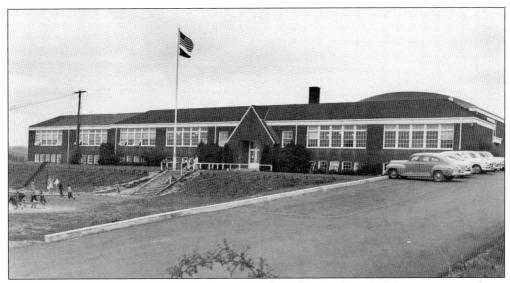

This view of Skyline School is from the early 1950s. The round roof of the gymnasium shows above the right side of the school. It was a later addition to the school. (Courtesy Dale Burger.)

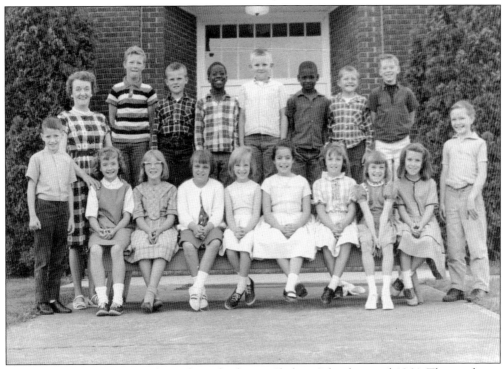

This is a combined third-and-fourth-grade class at Skyline School around 1964. The teacher is Helen Smith. (Author's collection.)

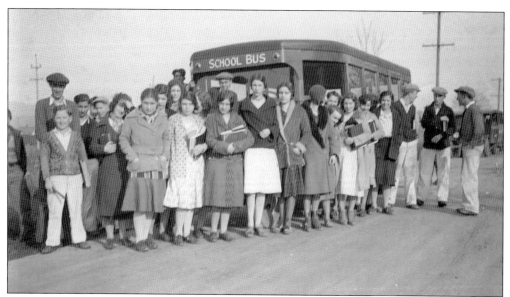

Many children around Bethany attended Beaverton High School. A school bus picked them up in Bethany, Helvetia, and other areas. In the 1930s and early 1940s, boys waited at Hans Cornils blacksmith shop, while the girls waited at Jeffries Store across the road at 185th and West Union Road. The photograph from 1931 shows the bus in Beaverton. (Courtesy Clark and Betty Dysle.)

Population increases in the surrounding community warranted the construction of a new high school. Sunset High School was built in Cedar Mill in the late 1950s. Sunset classes met in Beaverton High School for the first half of the 1958–1959 school year until the structure was completed in 1959. Many children from the Bethany area attended Sunset. (Courtesy Tom Robinson.)

Four

BUSINESSES

Ulrich Gerber and his family came to the Bethany area from Switzerland in 1876. They built their house that year and then in 1878 built the Bethany General Store. The Bethany Post Office was in the store. In this c. 1895 photograph, Gerber sits under the post office sign. Around 1900, he sold the contents of the store to Samuel Kunz. Gerber resigned as postmaster in 1900. Kunz was made postmaster in his store on NW West Union Road. (Author's collection.)

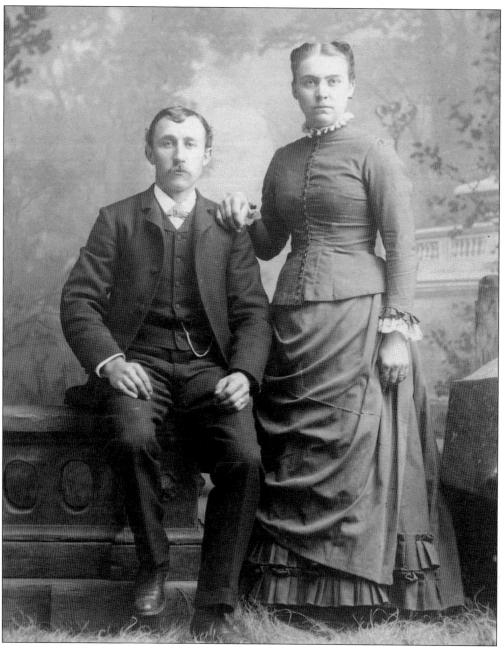

J. Fred Dysle, who was originally from Canton, Ohio, married Louisa Wismer in 1886. He moved his blacksmith business from Cedar Mill to NW West Union Road and 185th Avenue in 1887. His brother Arnold assisted Fred with the business for several years. Customers in the 1890s included Swiss pioneer Samuel Siegenthaler, prominent farmer John J. Kuratli, and general store proprietor Ulrich Gerber. Fred sold his shop in 1899 to Samuel Kunz and Charles Boy so he could farm full-time. (Courtesy Etta Barner.)

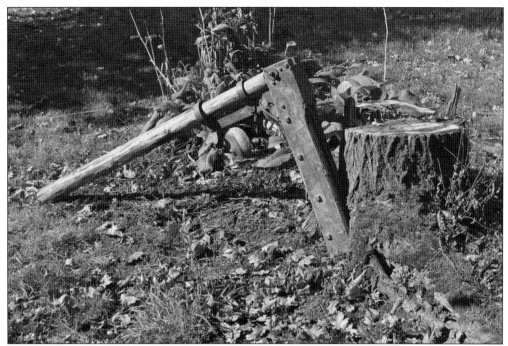

This is a stump jack made by J. Fred Dysle. A hole was dug under the edge of the stump, and the jack was put into position. The person operating it would lift the roots of the tree trunk to make it easier to be extricated from the ground by explosives or other means. (Author's photograph.)

Dec 29 1898	To repair iron	15
Jan 26	" dress wedge	15
Feb 9	" stump p. spring	25
Mar. 29	" sharp plow	25
April 27	" brick mould	1 25
" 29	" hook & ring in chain	25
May 23	" repair pitman put on knife head	25
		2 55

Fred Meyer had a brickyard at his farm on NW Springville Road and 185th Avenue in the late 1890s. This entry is from blacksmith J. Fred Dysle's business ledger, which shows that he repaired a brick mould for Meyer. Bricks were found on the ground for years. The nearby Hans Cornils house has bricks that were put in the walls for insulation when it was built. (Author's photograph.)

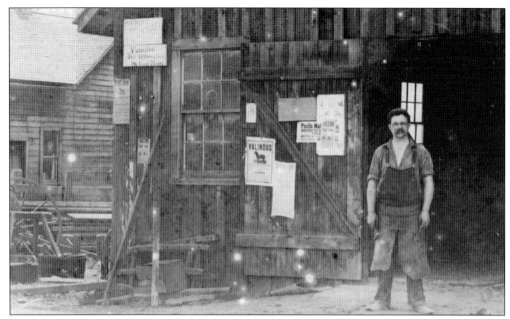

Hans Cornils became the Bethany blacksmith around 1905. In this c. 1910 photograph, Cornils stands in the doorway of his blacksmith shop, to the left is the Bethany Store. A poster advertising Percheron stallion Villindus's stud service is attached to the shop. Cornils would also go to farms to shoe horses; and he repaired autos as well. Cornils worked as a toolmaker in a Portland shipyard during World War II until his death in 1944. (Courtesy Mildred Joss.)

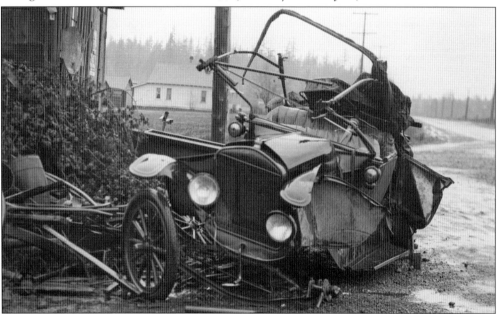

Fred Stoffer and a passenger in his automobile collided with a Standard Oil truck in early December 1932. It was at the intersection of NW 185th Avenue and West Union Road. His wrecked automobile was then moved next to Hans Cornils's Bethany Blacksmith shop. A news account states that Stoffer had a cut scalp, but it was much worse. Stoffer had a skull fracture and died later in the hospital. (Courtesy Ralph Stoffer.)

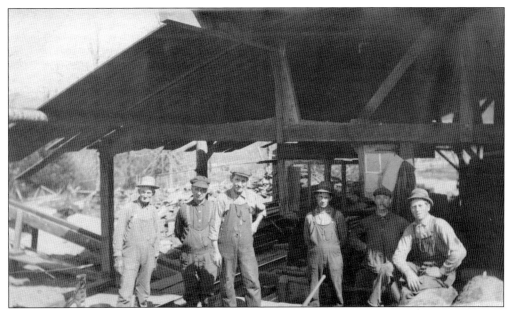

Lew Buell operated a sawmill on Wismer property west of NW Kaiser Road and south of the John Gerber farm. This view from the mill, which operated from 1913 to 1918, shows Buell and his crew. Buell is the man with the pinstriped shirt. He distributed real-photo postcard views of the sawmill to many in the community. (Author's collection.)

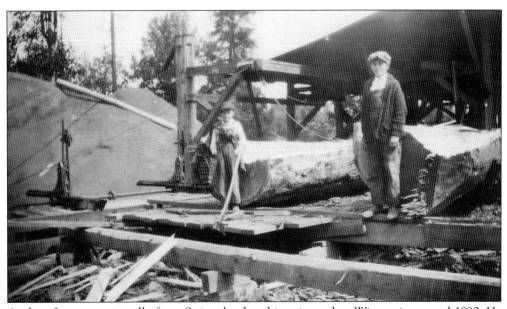

Andrew Leu was originally from Switzerland and immigrated to Wisconsin around 1890. He came to the Bethany area around 1920. He operated a sawmill with his son Ben from the 1920s to the 1930s. It was located on NW Springville Road west of Kaiser Road. It stood on the property later owned by Benny and Marguerite Gerber, which is now part of the Gerber Farms at Arbor View development. Don and Chuck Kraus, stand in the foreground of the mill. (Courtesy Laurine Grossen.)

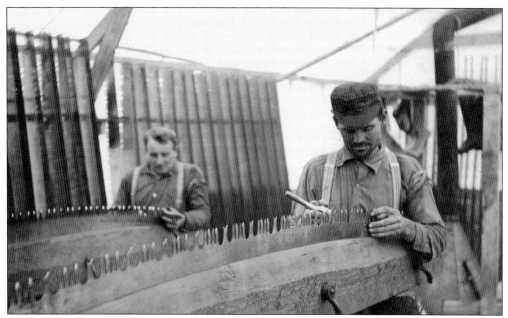

In this image from the 1910s, Ernest Schaer is sharpening a crosscut saw at a logging camp. At one time, Schaer worked for the Clark and Wilson logging company. A March 1922 news article in the *Hillsboro Argus* states that "Schaer is the road foreman out in his district and says he that he is going to forego filing in camps this season and try ranching and road making." The same article mentions that his wife had presented him with their third child—a girl. (Courtesy Jim and Sue Herman.)

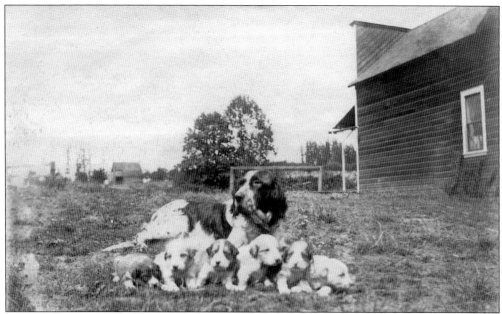

A Springer Spaniel and her six puppies lie on the ground next to the Bethany Store in the 1920s. A hitching post can be seen behind the dog's head. In the distance is a barn on Verne Dysle's farm, which had been established in the 1880s by his father, J. Fred Dysle. (Courtesy Ray and Beverly Kestek.)

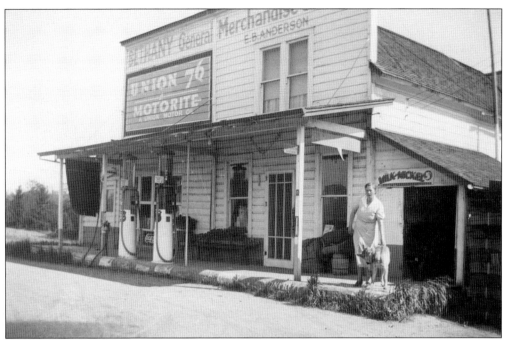

In the 1930s, the Bethany General Merchandise Store was operated by E.B. Anderson. Beginning in 1901, it had been owned in succession by the Kunz, Liesman, and Heckman families, until Anderson acquired it in the mid-1920s, later adding a mill south of the store. He operated the store into the 1940s. It was later owned by the Lundahls and the Elsassers. Other owners were James and Betty Lou White. The original store was in the right side of the building. (Courtesy Marvin and Ron Stoller.)

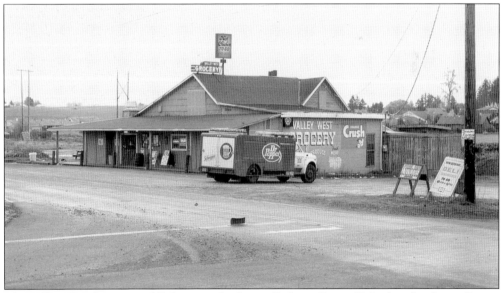

The Valley West Grocery and Deli was in the former Bethany General Merchandise Store. George Athanasakis bought it in 1977. During his ownership, it was renamed the Mad Greek Deli. Tom Kosmas joined Athanasakis in 1990 and later gave the business to his son Pondo. George retained ownership of the building. The deli closed in 2013. (Author's photograph.)

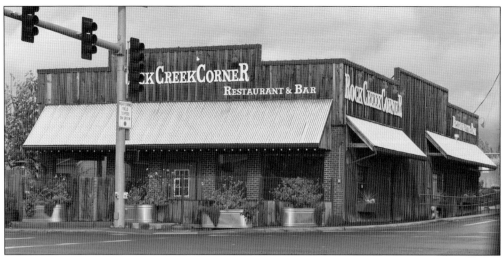

This store was erected at the corner of NW West Union Road and 185th Avenue in 1946 by Fred "Fritz" Zahler for Frank and Clara Jeffries Farmers' Cash Store. They sold groceries; Frank also had a barbershop at the store. They also sold hardware—and dynamite, which was later stored in a partially buried metal building. After the Jeffries retired, the structure was remodeled into three spaces used as rentals. Later, the Golden Goose Deli took over the building. The restaurant and bar shown in this recent photograph is Rock Creek Corner. (Author's photograph.)

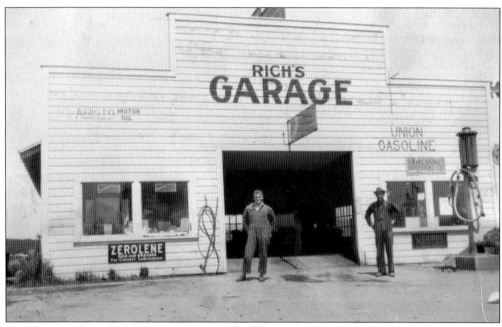

Detroit-trained automobile mechanic Theophil "Theo" Rich stands in front of his garage, which was on NW Cornell Road, in this 1920s photograph. His wife, Eleanor, operated a store in the left side of the building. When Sunset Highway was put through in the 1940s, this section of Cornell Road later became known as Bronson Road. Theo died in the 1940s. His brother Amos and wife, Janet, then operated the garage and the store. Used for other purposes later, the building burned in the early 1980s and was removed. (Courtesy Grace Jenne.)

Louis Siegenthaler's mill is in the center. Theo Rich's Garage and house can be seen on the left in this c. 1945 photograph. Both were located on NW Cornell Road. (Rod Eggiman photograph, courtesy Tony and Linda Smith.)

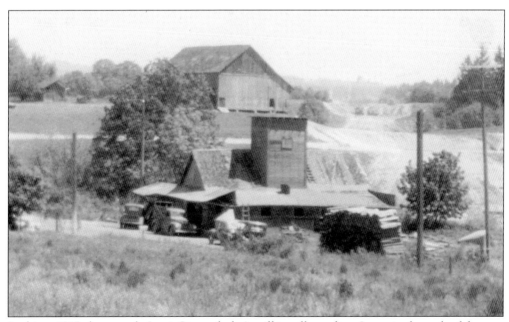

In this c. 1947 photograph, Louis Siegenthaler's mill is still standing. It was in the path of the new Sunset Highway (US Highway 26). The early grading of the highway is seen on the right side of the image. Siegenthaler relocated his operations to the former Zurcher barn, which was moved as part of the highway preparations. It stood on NW Cornell Road across from Eggiman family property. (Courtesy Tommy Thompson.)

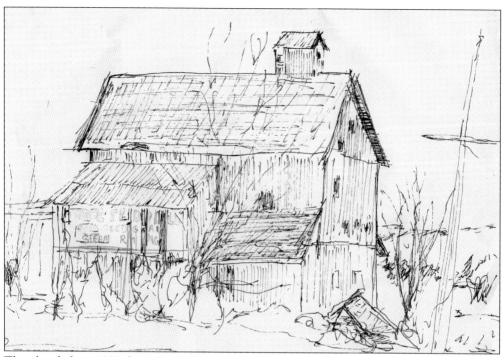

This sketch from 1982 shows Louis Siegenthaler's Sunrise Mill. It was purchased by the Kindel brothers in 1959. Siegenthaler died that year. The Kindels relocated their business to North Plains in 1966. Over the years, this structure became a picturesque ruin. It was torn down in the early 1990s. (Author's drawing.)

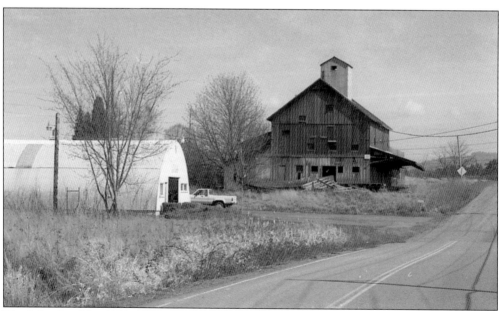

The left side of the 1980s photograph shows the Quonset hut that was home to Elroy Nofziger's upholstery shop. It was briefly used by Bassett Auto before it was torn down in the mid-1980s. (Author's photograph.)

48

Five

SOUTH OF
SUNSET HIGHWAY

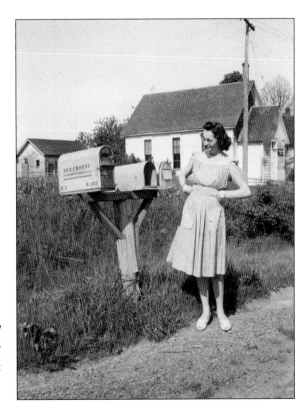

Around 1944, Doris Eggiman poses by mailboxes on the edge of Cornell Road across from her residence. The big mailbox is for her uncle Ben Croeni. The others are for her family and her grandfather's correspondence. In the background is the German Congregational Church of Cedar Mill, which was moved in the mid-1940s for construction of the original portion of US Highway 26, also known as Sunset Highway. (Rod Eggiman photograph, courtesy Tony and Linda Smith.)

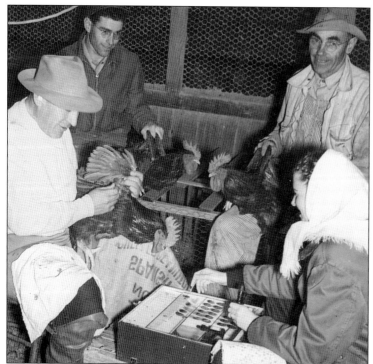

In this photograph from the 1950s, chickens are being given blood tests at the Eggiman and Son hatchery on NW Cornell Road near Sunset Highway. Clockwise from the left side are, unidentified, Carlton Eggiman, Carl Eggiman (Carlton's father), and Carlton's wife, Avalon. The hatchery was originally named Mountain View Poultry Farm and was operated by Carl's father Andrew. (Rod Eggiman photograph, courtesy Tony and Linda Smith.)

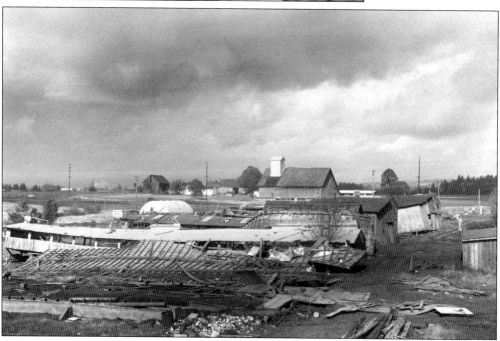

A fierce windstorm came through Oregon on Columbus Day, October 12, 1962. It cut a swath of destruction through many farms around Bethany. The Eggiman and Son hatchery had many chicken houses blown down. At left center is Elroy Nofziger's upholstery shop. At right center is Louie Siegenthaler's Sunrise Mill; he was the grandson of Swiss pioneer Samuel Siegenthaler. (Rod Eggiman photograph, courtesy Tony and Linda Smith.)

This c. 1900 view shows the Christian Zurcher family in front of their house on Cornell Road. Their farm's western border was on NW 173rd Avenue. From left to right are adopted son Oscar Hendrickson, Rosina Zurcher, adopted daughter Freda King, and Christian Zurcher. The young boy in the front is their son Frederick. Christian was a member of the German Congregational Church for several decades beginning in the late 1880s. The Zurchers came separately from Switzerland in 1887 and were married in Oregon in 1889. (Courtesy WCM.)

In the 1910s, Christian and Rosina Zurchers are seated in the back seat of their horse-drawn buggy. Their son, Frederick, is in front holding the reins. Their barn is in the background. The former Zurcher farm is now part of the Twin Oaks Business Park. (Courtesy WCM.)

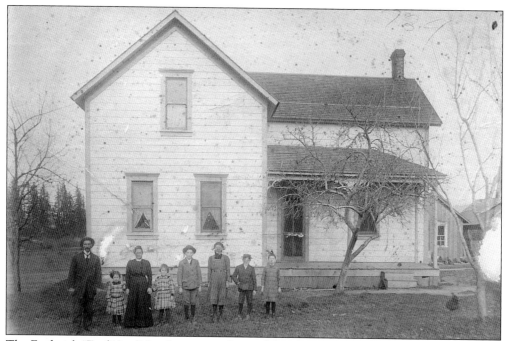

The Frederick "Fred" Losli family poses in front of their house on NW Cornell Road, near NW 173rd Avenue, in this c. 1912 photograph. Fred and Susannah "Susie" Losli had seven children. This view shows only six children as their son Edwin was born in 1914. (Courtesy Mike Losli.)

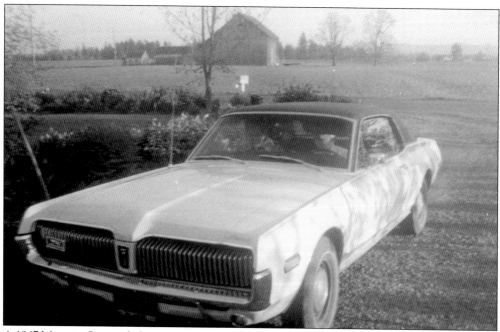

A 1967 Mercury Cougar, belonging to relatives of the Edwin Losli family, is parked in their driveway off of NW Cornell Road. Christian Zurcher's barn is at the top of the late-1960s photograph. (Courtesy Mike Losli.)

Winslow Brownson and his wife's Donation Land Claim of the 1850s was on the south side of NW Cornell Road, not far from today's 185th Avenue. The building behind the Peter Grossen family was the Brownsons' pioneer house. The one in the background was built later. Peter lived on the property in the 1890s. A creek that ran through the property has been known as Bronson Creek. According to longtime dairy farmer Donald "Don" Meier, the creek's name is wrong and should be Brownson. This photograph is from the mid-1890s. (Courtesy Reichen family.)

John Meier Sr. and his son John bought the remaining Brownson property in 1909. John Jr. married Theresa Kerhli in 1917; they lived in the two-story house. Albert Meier, who married Emma Dysle in 1920, built a new house where the older Brownson home was. This view from the early 1920s shows a tree being topped. John Meier's house in on the left. Albert Meier's is on the right. (Courtesy Reichen family.)

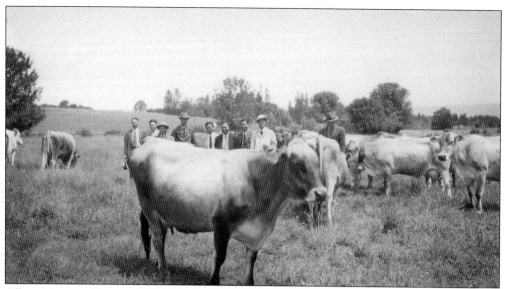

Albert Meier and his son Don had a prizewinning herd of registered Brown Swiss cows on their dairy located on the north side of NW Cornell Road, bordering NW 185th Avenue. They had many visitors come to their farm from across the United States. This view from the 1940s includes Asian visitors inspecting the herd. Albert's father, John, bought his first Brown Swiss cow in 1915. Albert bought several cows from his father's registered herd when they were sold off at auction. (Courtesy Reichen family.)

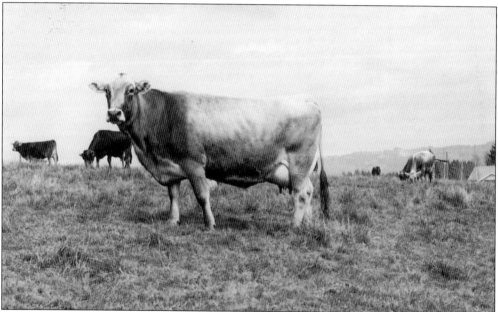

Pictured in the 1950s is Brown Swiss cow Arbor Rose Mac Ruby, standing in the pastureland on Albert and Don Meier's dairy farm, which is now part of Tanasbourne Town Center area. The cow was born on the farm around 1948. In 1959, Arbor Rose Mac Ruby was bought by Lee Hill Farm of New Vernon, New Jersey. Around 1960 or 1961, she was named grand champion female at the National Brown Swiss Show. Albert and Don Meier relocated the dairy to Scappoose, Oregon, in 1954. (Courtesy Reichen family.)

Niels Hansen came to Oregon from Denmark in 1883 and married Mary Rasmussen in 1888. They had a farm on NW 185th Avenue and Cornell Road. This photograph of their house and family is from about 1899. From left to right are (back row) Niels, Harry Hansen, Aunt Belle Pederson, and Mary Hansen. Jesse Hansen is in the front row. In 1912, Niels built a new house, which was later moved. On the former Hansen property today are the Lakes Apartments. (Courtesy John Hansen.)

This farm scene from the late 1890s shows Harry Hansen on the horse. Niels is next to the wagon. To his right are Jesse Hansen, Aunt Belle Pederson, and Mary Hansen. Mary Hansen's sister Caroline Rasmussen and her mother, Fredericka, lived on a farm across NW Cornell Road from the Hansen family. Caroline sold it to dairy farmer Don Meier in 1943. (Courtesy John Hansen.)

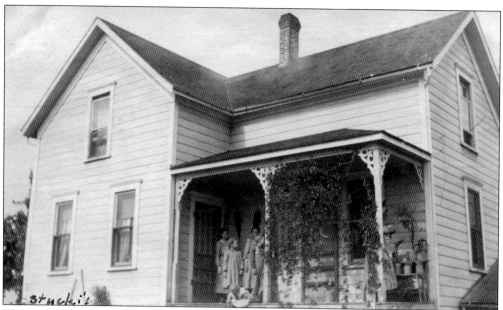

This a photograph of the Fred Stucki house from about 1920 or earlier. It was built in the late 1880s. Fred and his wife, Maria, came to the Bethany area around 1887; they had three children. Maria died in 1892; Fred remarried in 1895. Several children are on the porch. The Stucki home is very similar to the Fred Losli, John Meier, and Fred Berger Sr. houses. It originally stood west of NW 185th and south of Sunset Highway. (Courtesy Ray and Beverly Kestek.)

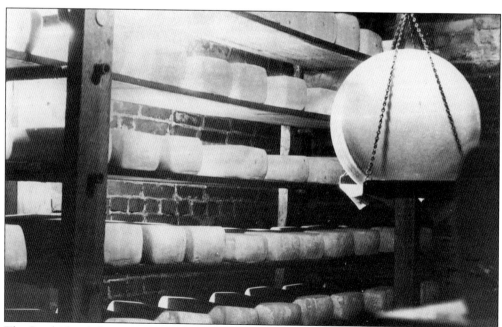

The Stucki family began making cheese in the 1890s. Esther Stucki continued with the cheese-making tradition for several decades. This is a 1934 view of the building on the Stucki farm where the cheese was stored during the aging process. (Courtesy Ray and Beverly Kestek.)

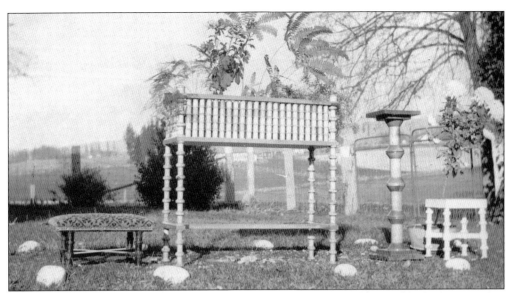

Esther Stucki made creative use of old wooden spools. This shows a sampling of her handiwork around 1932. Various plant and flower stands were made by her. The legs were formed with the spools. Bethany Presbyterian Church used her tables to display flowers around the church. (Courtesy Ray and Beverly Kestek.)

After a European trip, Esther Stucki poses with her luggage with stickers from the various cities and countries that she visited, which included Germany and Switzerland. (Courtesy Ray and Beverly Kestek.)

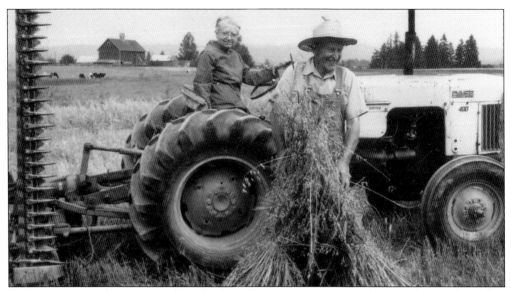

Esther Stucki, on the tractor, and her brother Walter are seen in this photograph from the 1960s. They lived out their lives on their family farm south of Sunset Highway (US 26) and NW 185 Avenue. Over the years a variety of people assisted Walter during harvest time. Walter told people that his sister was his best farmhand. They were very thrifty; he made rope and she made their undergarments. (Courtesy Gene and Launa Zurbrugg.)

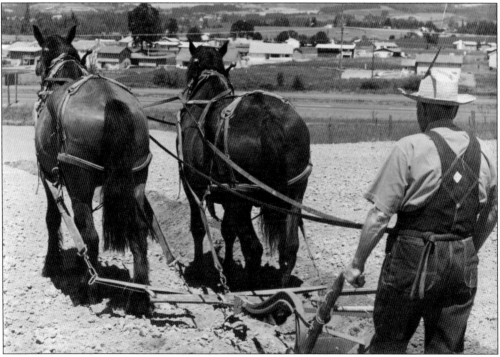

For many years, Walter Stucki farmed with horses. After he switched to motorized farm equipment, Stucki kept some horses around for small jobs and exhibition purposes. He is seen is this 1968 photograph with a view looking towards the Rock Creek development. (Courtesy Gene and Launa Zurbrugg.)

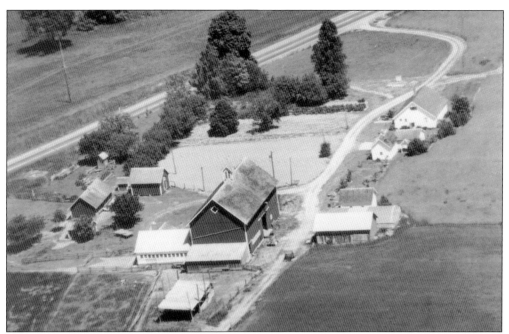

Walter and Esther Stucki's farm could be accessed directly from US Highway 26 until a second lane, in each direction, was added to the highway in 1964. Their driveway was relocated to NW 185th Avenue south of the highway. (Courtesy Gene and Launa Zurbrugg.)

Walter Stucki sold his property and barn in the mid-1980s. There were great efforts made to dismantle the barn, which was built around 1916, for later reassembly. Confusion over which organization was going to take the responsibility to perform the reassembly work led the project to stall. The barn wood deteriorated over the years and was later disposed of. (Courtesy WCM.)

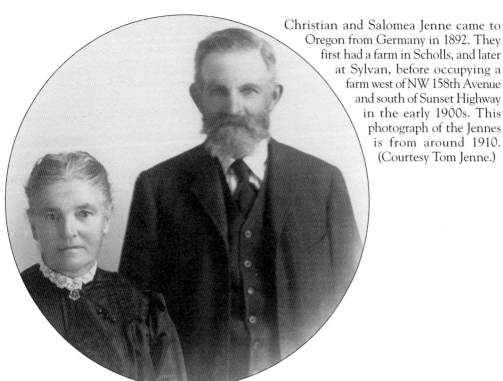

Christian and Salomea Jenne came to Oregon from Germany in 1892. They first had a farm in Scholls, and later at Sylvan, before occupying a farm west of NW 158th Avenue and south of Sunset Highway in the early 1900s. This photograph of the Jennes is from around 1910. (Courtesy Tom Jenne.)

The Jennes' house was still standing in the late 1970s at the end of a long driveway off of NW Walker Road. The Waterhouse development was built on Jenne land beginning in the mid-1980s. (Author's photograph.)

Six

NORTH OF
SUNSET HIGHWAY

This photograph from the early 1940s shows the end result of daredevil activities on NW Cornell Road. Young men would try to drive their automobiles as fast as they could without sliding off the road. This attempt was not successful. (Courtesy Tommy Thompson.)

John J. Lehman sits on a wagonload of hay somewhere in the Bethany area. Farmers took hay to various customers in Portland. Benny Gerber told the story that the bridge keeper of the new the Broadway Bridge of 1913 told his father John that his load of hay was the first wagon to go across the span. (Courtesy Joan Krahmer.)

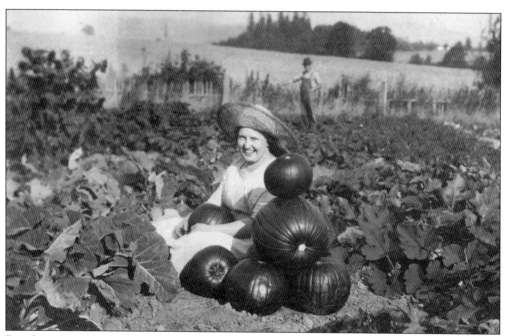

Ben Croeni, a prosperous farmer, stands in the background of his garden. His wife, Lily, sits with a stack of pumpkins in this 1920s photograph. She was the daughter of former Bethany Baptist Church pastor Wilhelm Schunke. Ben and Lily were married in 1921. They lived north of Sunset Highway near today's NW Bethany Boulevard. (Courtesy Grace Jenne.)

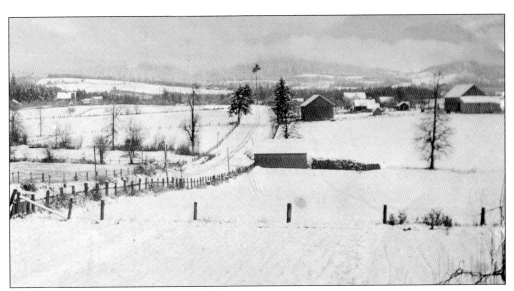

The c. 1918 photograph above was titled *Trail to the Lonesome Pine*. The trail was NW Cornell Road. The lonesome ponderosa pine stands in the center. Its branches had the dubious honor of being a target for sharpshooters, who stripped the tree of its lower branches many years before. The Lehman farm stands at the upper right. This image was taken by Eleanor Eggimann, who later married mechanic Theo Rich. Years ago, according to her father, Andrew Eggimann, the snow so heavy and the tree was so bent over that a hay wagon could not go under it. The lonesome pine is also referred to as the lead tree in *Cedar Mill History*. It is pictured at right in the late 1940s on the south side of Cornell Road by the Dubys' house, near the future site of a service station. The tree was damaged during the Columbus Day storm in 1962. By the early 1980s, it was considered a hazard and was taken down. (Above, courtesy Grace Jenne; right, courtesy Tommy Thompson.)

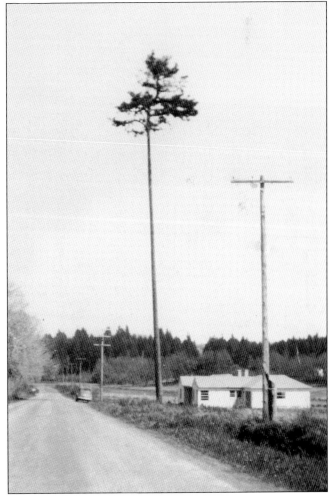

Samuel Siegenthaler's second wife, Margareth Stalder Siegenthaler, stands in front of her home in this c. 1900 photograph. His first wife, Elizabeth, died in 1891. Samuel passed away in 1899. (Courtesy Doug and Bernietta Graf.)

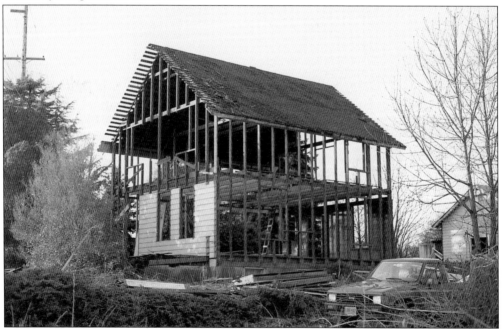

This home, which had been occupied by Adele Guerber, granddaughter of Samuel Siegenthaler, was being dismantled in the 1980s. The wood was going to be used for another building project. (Author's photograph.)

Adele Guerber, a daughter of Alfred and Rosette Guerber, was born in Helvetia. She found work in Portland, Oregon, in the 1910s. Adele came back to her parents' farm in Helvetia to help out. When they moved to Beaverton to live in her grandfather Samuel Siegenthaler's former house, Adele came with them and her invalid brother, Walter. In the mid-1930s, she agreed to take care of a young boy named Edward "Tommy" Thompson, who needed to live in a stable environment. She also continued to take care of her brother until his death in 1969. (Courtesy Tommy Thompson.)

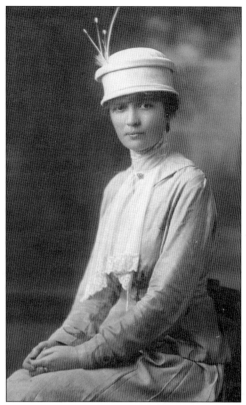

Tommy Thompson stands next to his automobile, a 1929 Model A Roadster that he drove to his job at Albina Engine and Machine Works, which made subchasers, landing crafts, and other ships during World War II. In the background are the Theo Rich house, Louis Siegenthaler's mill, and a barn on the Lehman farm. This photograph is from around 1943. (Courtesy Tommy Thompson.)

The John Meier farm, on NW 185th Avenue, extends southward from today's Bronson Road to part of the Tanasbourne Town Center area. Their house faced NW 185th Avenue in the vicinity of the west end of Bronson Road. (Courtesy John Hansen.)

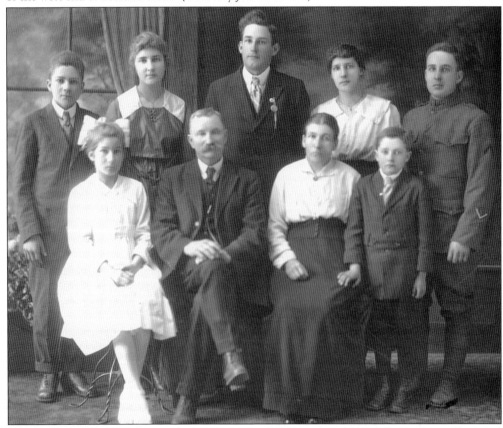

John Meier's family poses for a studio portrait around 1918. Pictured from left to right are (first row) Louise (Tuller), John Meier (father), Magdalene Meier (mother), and Werner Meier; (second row) Ed Meier, Marie (Berger), John Meier, Albert Meier, and Ida (Hansen). (Courtesy John Hansen.)

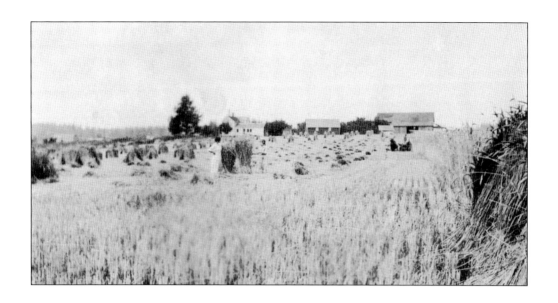

The above view of the farm is from the 1910s. John Meier's house, barn, and farm outbuildings are in the distance. The grain field is in the process of being harvested. The construction of Sunset Highway (US Highway 26) in 1947 divided the farm, then owned by his son Albert and grandson Don. A small underpass was built beneath the highway so their Brown Swiss cows could move across their divided property. The modern comparative view is looking to the north from the south side of Sunset Highway. (Above, Courtesy John Hansen; below, author's photograph.)

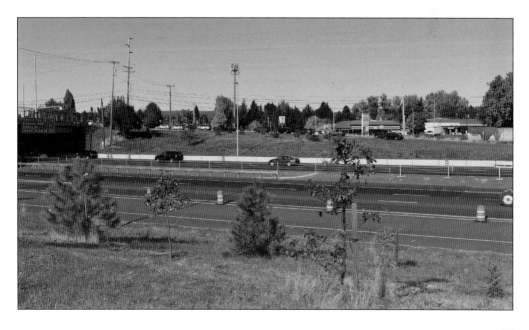

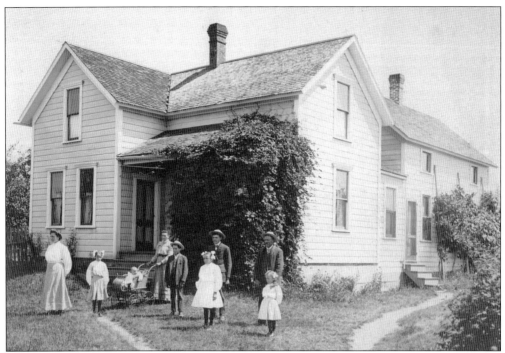

Located on the east side of NW 185th Avenue, Fred Berger Sr.'s farm was developed into the Somerset West Park View neighborhood beginning in the early 1960s. His farmhouse dates to the 1890s and had an addition built in the back to accommodate his large family. The photograph dates to 1900. The family is identified as including Berger's wife, Rosa, with the baby, Buggy, and Fred Sr. on the far right in the background. (Courtesy Bob and Beverly Yungen.)

This view from approximately 1964 shows a portion of the Somerset West subdivision and the start of the Rock Creek development. The farm above NW 185th Avenue, at the center of the photograph, was originally the Fred W. Berger farm, which was replaced by Rock Creek School. Above to right is the William "Bill" Jeffries farm. At right center, below the road, is the Simon Berger farm. At the bottom of the photograph is the first phase of the Park View development. (Courtesy WCM.)

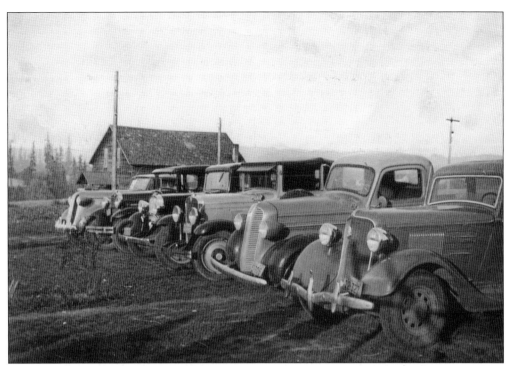

A row of cars is parked at Chris Allenbach's front yard in 1936. Across NW West Union to the north is the hall that his parents built to have Salvation Army meetings. The long-abandoned structure blew down in 1962 during the Columbus Day storm. (Courtesy Jean Hoffelner.)

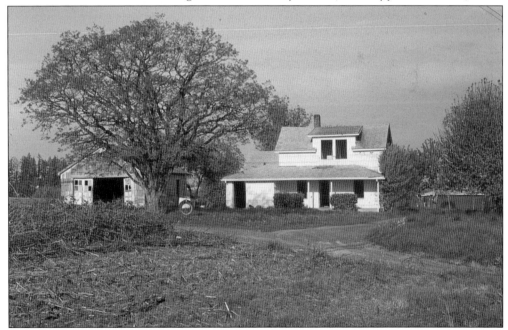

The old Allenbach house, at NW 174th Avenue and West Union Road, with windows taken out, awaits its fate of being removed in 1986 as part of making way for the Allenbach Acres subdivision. (Author's photograph.)

When Bethany farm children became teens, some would go to Portland to work to earn an income to help support their family; some worked as housekeepers. Mary Wyman grew up on her family's farm north of today's Sunset Highway bordering Bethany Boulevard. She was a cook for William S. Ladd's Hazel Fern Farm in northeast Portland around 1897. (Author's collection.)

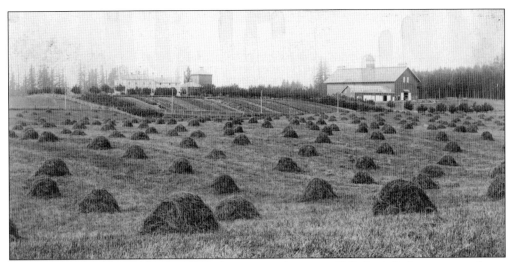

William S. Ladd was a Portland pioneer who came to the city in 1851. Initially, he was a merchant, and prosperity followed. Ladd became a civic leader and banker and was also a gentleman farmer who owned several farms. The 462-acre Hazel Fern Farm, which also contained a dairy, later became Laurelhurst, a housing development in northeast Portland that was started in 1910. (Author's collection.)

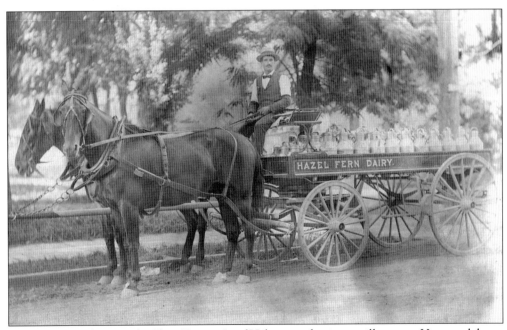

In this c. 1900 photograph, Chris Yungen Jr. of Helvetia is driving a milk wagon. He was a laborer at Ladd's Hazel Fern Dairy in northeast Portland. Yungen was employed by the dairy in the late 1890s and early 1900s. (Courtesy Bob and Beverly Yungen.)

Cousins from the extended Luchs family pose at Dickie Luchs's birthday party near Bethany in 1950. It was at his parents' farm, which was entered from NW Cornell Road. Many from the Luchs family of Milwaukie, Oregon, married other Swiss in Bethany. The house in the background was built by Arnold Wyman for his grandmother Marie Graber. The Grabers and Wymans emigrated from Switzerland to the Bethany/Cedar Mill area in the mid-1870s. Arnold Wyman's daughter Frances married John Luchs. (Author's collection.)

Mark Anderson is standing on the wagon, with his father, Art, in front in this photograph from the 1950s. The Anderson farm was on NW West Union Road. They are working in their field that is now part of Avamere at Bethany, an upscale senior living community. It also offers assisted living and memory care. (Courtesy Mark and Bev Anderson.)

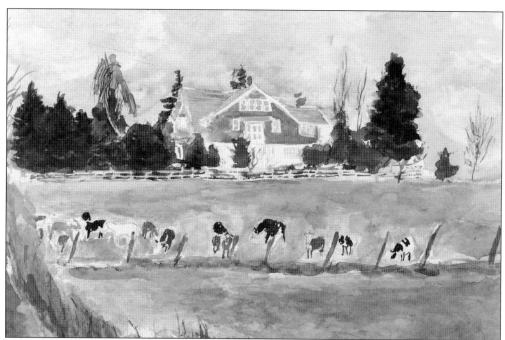

In the early 1980s, cows still graze in the field next to the John Croeni house, which was built in 1905. Croeni and his wife, Lydia, lived in the house for many years. He was the son of Bethany Baptist Church's second pastor. Eventually, the property was developed, leaving the house and a large yard. Due to the widening of today's NW Bethany Boulevard, a block wall enclosed his front yard. (Author's painting.)

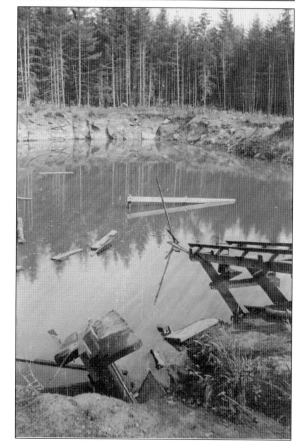

In April 1901, C.E. Wismer completed the tramway to a Bethany-area rock quarry. Soon after, the rock crusher was installed. This gravel quarry, near the east end of the Abe Stoller property, supplied material used for paving the muddy roads around Bethany. Stoller would back his wagon in to have the gravel loaded. Ground springs filled the quarry with water on occasion. This c. 1918 view to the north shows debris in the water. It is now Quarry Pond Park and is located behind Stoller Middle School. (Courtesy Ray and Beverly Kestek.)

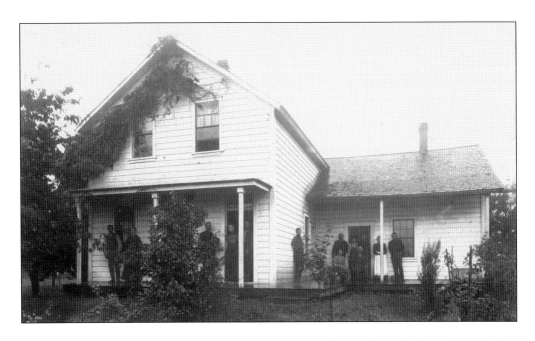

The Jacob Wismer house on NW Kaiser Road, near NW Laidlaw Road, was built in 1879. Members of the Wismer family, except for one son, stand under the porches on a rainy day in this early-1900s photograph. By 2005, a new housing project was erected around the Wismer house, which had been remodeled and added on to as well. The newer image is from 2017. (Above, author's collection; below, author's photograph.)

The Wismer farm on NW Kaiser Road had an 11,000-square-foot barn built in 1897. Around 1940 Bethany carpenter, Fred Zahler, built an addition to it for Carl, Ray and Dick Wismer's dairy. Zoning issues stalled the efforts of the modern day owners to preserve the large barn. It was dismantled in 2000, though the addition still stands today. (Above, courtesy Ray and Beverly Kestek; below, courtesy Ron Wismer.)

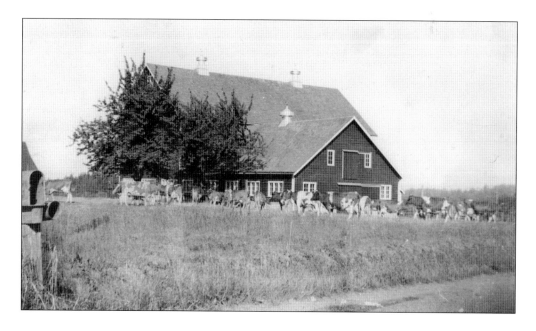

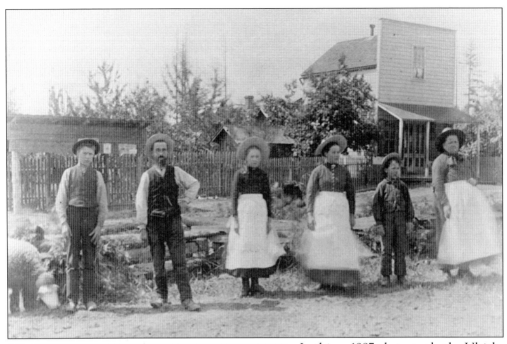

In this c. 1887 photograph, the Ulrich Gerber family pose across NW Kaiser Road from his general store and Bethany Post Office. Pictured from left to right are John Gerber, Ulrich Gerber, Minnie Gerber, Elise Gerber, Sam Gerber, and Anna Barbara Gerber. (Courtesy Fishback family.)

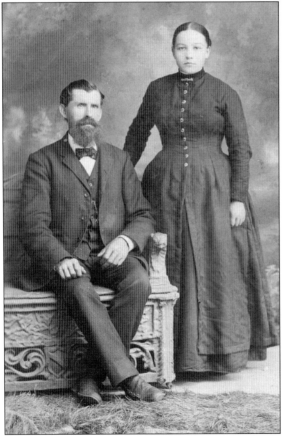

In the late 1880s after his wife died, Friederich Frederici came from Chicago to Oregon with his four children and settled in the Stafford area. Elise, the daughter of Bethany storekeeper Ulrich Gerber, married Friederich in 1889 and moved to Stafford when she was 17 years old. Elise and Friederich had two children that lived; she and a baby died during childbirth and were buried together when Elise was only 21. (Author's collection.)

In 1979, the Ray Taennler family renovated the home of his great-grandfather Ulrich Gerber. Gerber had his home built in 1876, and a store building was added soon after. The Bethany Post Office was located in the store until 1900. The Gerber house was also a stagecoach stop. The Tualatin Valley Heritage Society presented a plaque to the family in a ceremony celebrating the history of the site. (Author's photograph.)

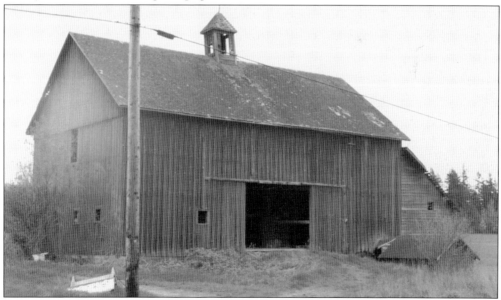

There was a series of barns fires around Bethany in 1974. The old barn on the former John Gerber property, on NW Kaiser Road near Springville Road, was one of the structures burned as a result of arson that year. This photograph shows the Gerber barn as it looked early that year. (Courtesy WCM.)

The photograph of NW Kaiser Road, south of Springville Road, shows the widening of NW Kaiser Road to accommodate increased traffic due to development in the Bethany area. The Ulrich Gerber house is in the right background. In the process, the thoroughfare was excavated during construction and was made lower than the existing road. Then the original road was lowered. New construction is seen in the left background. The modern photograph from 2017 shows increased change, with land divided into housing developments. (Both, author's photograph.)

The corner property seen in this 1982 view looking east from NW Kaiser Road and Springville Road was originally part of the Jake Stoller farm, which was across the road to the north. Beyond the pump house and the oak tree was the barn at the Paul and Peggy Seger farm, which was earlier owned by the Franzen family. In the late 1990s, the property was sold, as were the Seger property and the Gerber farm. The land was redeveloped into housing. It is now part of the Gerber Farms at Arbor View housing development. The 2017 photograph shows the brick wall of the development bordering NW Kaiser Road. (Both, author's photograph.)

This is a c. 1985 view of the Jake and Emma Stoller house. The one-story section with the thicker chimney was built in the 1880s for a pioneer Swiss settler, Jacob Brugger, who came to the area in the 1850s. The two-story section was built by Jake Stoller sometime after he purchased the property in 1906. The old house was used for a fire department practice burn in 1986. This property is now part of the Crossing at North Bethany subdivision. (Author's photograph.)

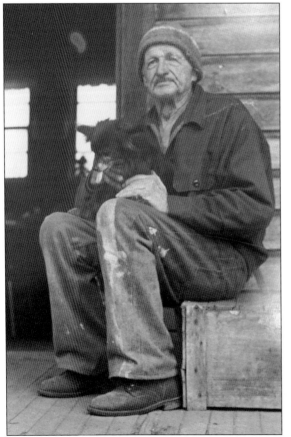

Ralph "Red" Stoller and his dog sit on the porch of his house in this late-1970s-era photograph by an unidentified photographer. The youngest son of Jake and Emma Stoller, Red was the last resident of the house. (Courtesy Gene and Launa Zurbrugg.)

This 1937 photograph shows children at Japanese Americans Yosinosuke and Asasno Sato's farm, where they picked a variety of berries and vegetables. After the Pearl Harbor attack on December 7, 1941, triggered America's entry into World War II and Pres. Franklin D. Roosevelt's Executive Order 9066 forcing Japanese Americans into internment camps, the Satos were sent to the assembly center at the Portland Stockyards. They were then sent by train to the Minidoka internment camp. Area farmers kept watch on their farm as well as the farmer that the government assigned to take care of the farm. The Satos came back to the farm after the war. In 2013, the old Sato garage was removed, and development started soon after. The view below is an approximate modern comparative view of the view depicted above. (Above, courtesy Jim and Sue Herman; below, author's photograph.)

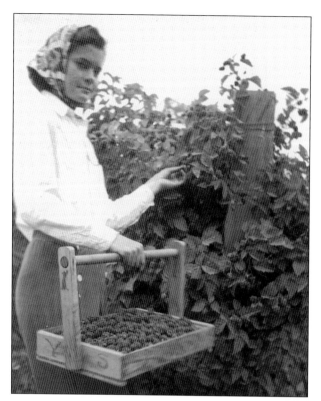

Louise Schaer, a nearby neighbor of the Satos, is picking berries at their farm in this late-1930s photograph. She holds a berry carrier that has Yoshinosuke Sato's initials. (Courtesy Jim and Sue Herman.)

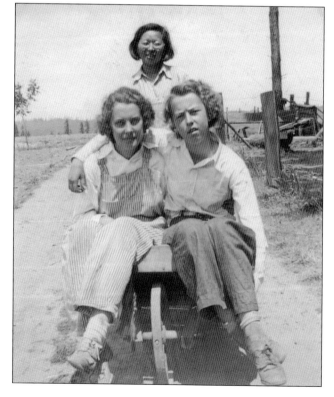

Three girls are taking a break at the Sato farm in this late-1930s photograph. Eleanor Schaer and Lucille Gerber are in the front of the wheelbarrow; Marie Sato is in back. Eleanor and Lucille are two of the neighboring girls who picked berries at the Yoshinosuke and Asano Sato farm. Marie was one of the Sato daughters. (Courtesy Jim and Sue Herman.)

Berry pickers Andy Huserik, on the left, and Norman "Timmie" Toelle, with berry-stained hands, stand between the rows at Sato's farm. The Sato house is in the background. (Courtesy Jim and Sue Herman.)

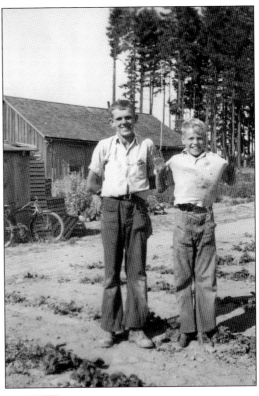

Shin Sato, eldest son of the Satos, was part of the Japanese 442 regimental combat team of the United States Army during World War II—as was his bother Roy, who was injured twice. Shin, who went to Bethany School, Beaverton High School, and Pacific University, was killed in action in 1944. His remains were returned for burial in Bethany Presbyterian Cemetery in 1949. (Courtesy Randy Gerber.)

This house, photographed in 1979, was the former parsonage of Bethany Baptist Church. It was built in 1882. According to longtime resident Fred Pfister, it was moved in 1923. Fred had been working at neighbor Emil Stalder's farm and saw it being moved north, from its original location, to NW Kaiser Road across from the Bethany Presbyterian Church cemetery. Many families lived in the house over the years. The farmland and house was sold to the Beaverton School District. The new K–5 school, Sato School, was built on the land and opened in 2017. It honors the Sato family, who had a nearby strawberry farm. (Both, author's photograph.)

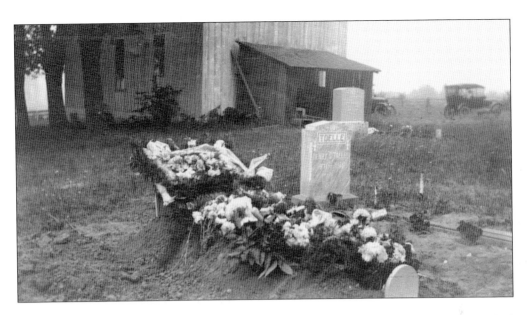

Hermann Toelle, a Bethany area farmer who lived off of NW Kaiser Road on Toelle Lane, died in 1918 and was buried next to his son Henry in the Bethany Presbyterian Cemetery. In the background is the old Bethany Presbyterian Church, which was no longer needed for worship services when a new building was erected in 1905. After that, the old building was used on occasion for memorial services. Below, a 2017 view (of the location in the above image) shows that the old church is gone. It was removed before 1936. Henry Toelle's headstone is no longer upright and is flush with the ground. The large headstone on the left marks the graves of Hermann and his wife, Amelia. (Above, courtesy Alan Toelle; below, author's photograph.)

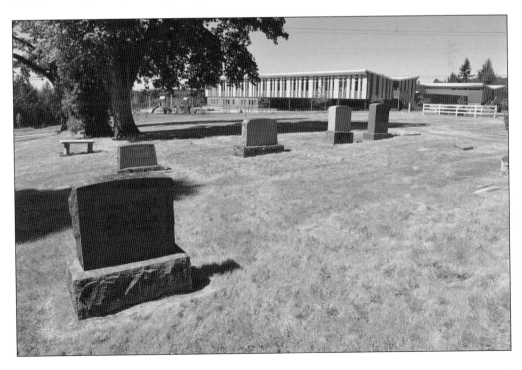

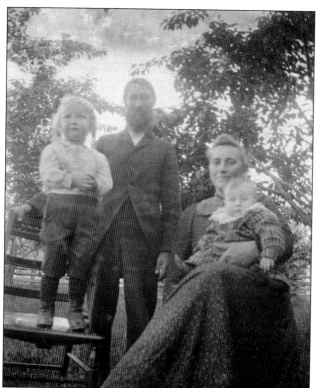

Dr. Adolph Von Gruenigen married Ida Wismer in 1895. They built a house on the farm they leased on NW Germantown and Kaiser Roads. This c. 1898 image shows their first two children. A neighbor, who was squatting on part of their land, tormented the family, which provoked a protracted verbal war of words with Von Gruenigen. The neighbor swung a shovel at the doctor; the doctor then responded with a blow with the butt end of his rifle on the assailant's head, fracturing the man's skull, which resulted in his death. Although Von Gruenigen was cleared of wrongdoing, he was advised to move, which he did, relocating his family to California in 1901. (Author's collection.)

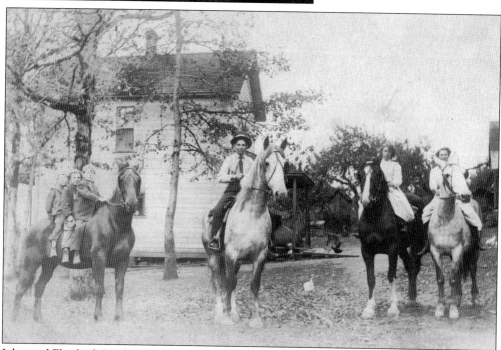

John and Elizabeth Linder purchased Von Gruenigen's house and leased property in 1905. This c. 1910 photograph shows six of the Linder children on horses in front of the original house. John Linder built an addition on the west side of their home around 1913. (Courtesy Steve Cook.)

John Linder came to the United States from Reichenbach, Switzerland, in 1880 and married Elizabeth Etter. Originally, they lived in a log house on property east of Kaiser Road, which he later sold to Kendall Barker. (Courtesy Etta Barner.)

The John Linder family poses inside and in front of their automobile in this c. 1918 photograph. Their house is in the background. (Courtesy Etta Barner.)

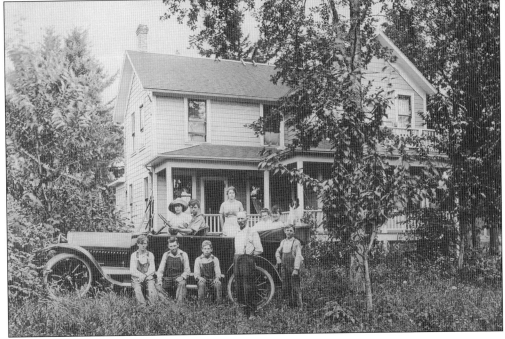

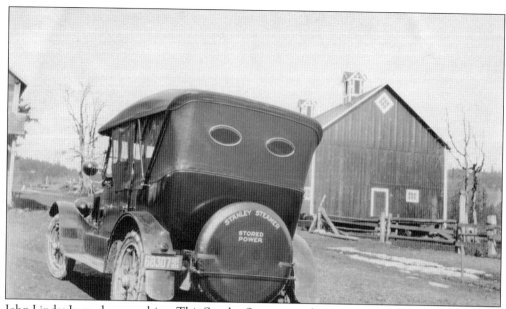

John Linder Jr. made moonshine. This Stanley Steamer made it possible to make a quick getaway in case he was pursued by police. This photograph is from 1923. (Courtesy Steve Cook.)

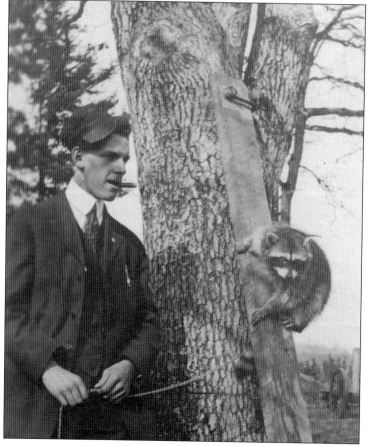

John Linder Jr. is shown in this c. 1920 photograph with his pet raccoon. This was probably taken at the Linder farm on Sauvie Island near the Willamette River north of Bethany. (Courtesy Steve Cook.)

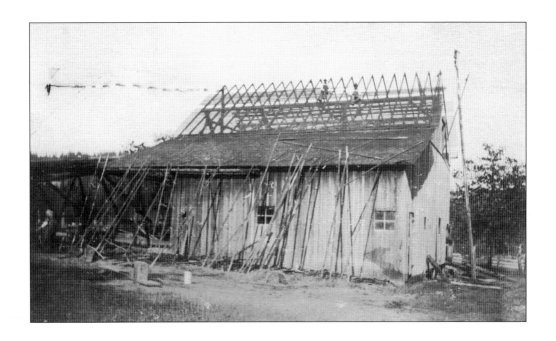

In the early 1920s, the old barn on the Linder Farm, on NW Kaiser Road, was partially dismantled to enable the structure to be enlarged. Above, men are on the roof of the structure. The image below is the view of the barn after it was completed. (Both photographs courtesy Steve Cook.)

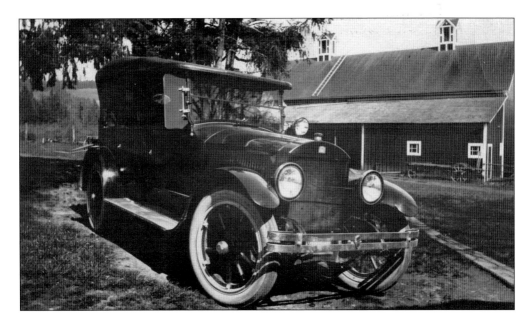

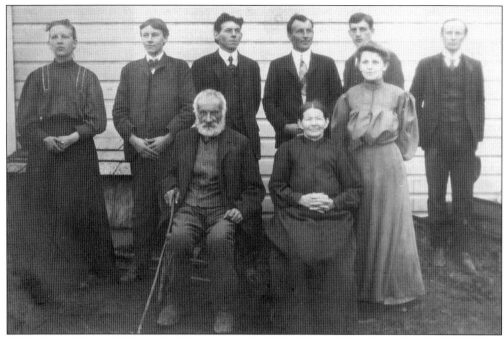

Christian and Anna Barbara Luethe came to the United States from Switzerland in 1877. They had a farm near the Toelle Farm on NW Kaiser Road above Germantown Road in Washington County. In this c. 1905 photograph of the Luethes are, from left to right, (first row) Christian (father), Anna Barbara (mother), and Annie; (second row) Rose, Albert, Sam, John, Chris, and Fred. Christian died 1906, his wife in 1925. An excerpt from her obituary reads, "The bible was her precious companion and the food for her soul. Mother Luethe was a loving mother, always concerned about the souls welfare of her children and continually admonishing to a better Christian life." (Courtesy Dale Burger.)

Neighbors Bill Toelle and Albert Luethe pose next to an outbuilding in this c. 1900 photograph. Albert is holding a basket, and another basket is on the ground. At one time, the Toelles were well known for their basketmaking skills. (Courtesy Dale Burger.)

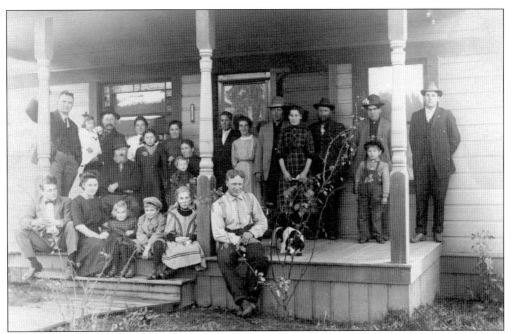

This is an extended family gathering at Albert "Dutch" Toelle's house on NW Toelle Lane, around 1912. Included in the photograph are his wife, Lizzie, and people from the Toelle, Meier, Grossen, and Alplanalp families. Dutch is at the right center, seated next to a porch support. (Author's collection.)

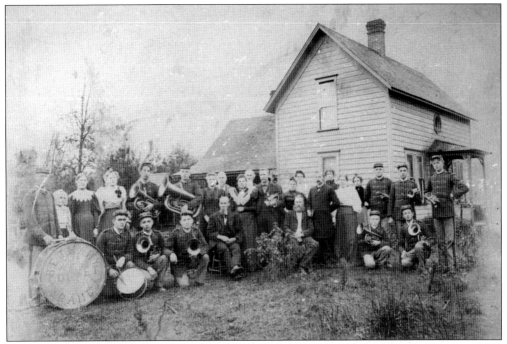

The Bethany Cornet Band performed at the wedding of Fred Toelle and Estella Forest in 1897. The event took place on Sauvie Island next to the Willamette River. Fred was a band member; he can be seen at center holding an instrument. (Courtesy Alan Toelle.)

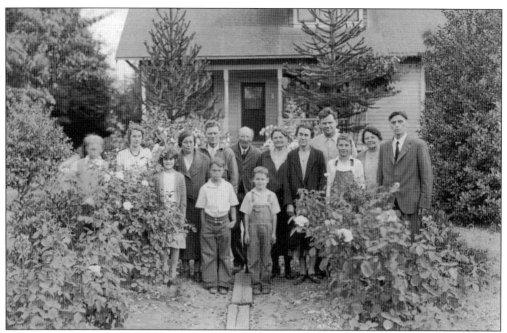

This is a view of the extended Schaer family at Ernest and Hedwig Schaer's house on NW Springville Road. The man in front of the door is John Schaer, a Swiss pioneer who came to the Bethany area in 1876 and moved to the Mountaindale area, several miles west of Bethany. The second person to the right is Hedwig Schaer. To her right is her husband, Ernest, who was the son of carpenter Friedrich Schaer. (Courtesy Jim and Sue Herman.)

This house was part of the Carsten Hansen Farm on NW Springville Road near 185th Avenue in 1909. Later, the farm was also owned by Henry I. Kuratli and Christian Schindler. Walt Allenbach was the final owner before it was purchased by Portland Community College for its Rock Creek Campus. In 2015, the house was torn down, displacing its final occupant, a skunk. (Courtesy Reichen family.)

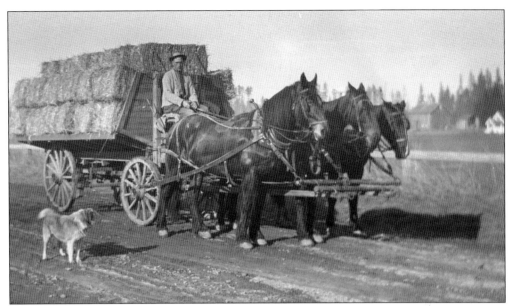

Ben Graf is at the reins of his hay wagon in the 1910s on NW Springville Road. The farm in the right background was the Samuel "Sam" Joss Farm. The site is now part of the Arbor Oaks housing development. (Courtesy Doug and Bernietta Graf.)

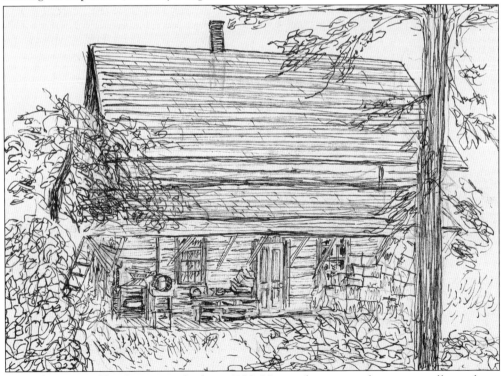

The Johann Graf log house was built in 1876. Having been moved twice, it still stands on family property off of NW Springville Road. Ernest and Hedwig Schaer lived in the log house after their marriage in 1914 while he was building their home, which was completed in 1915. (Author's drawing.)

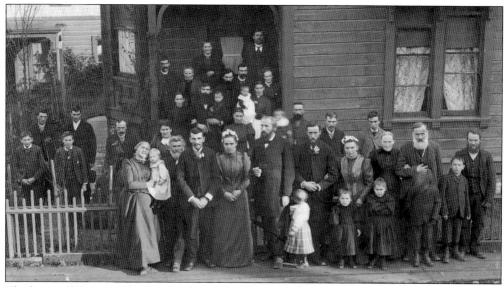

The home of Gustav Scheel in southwest Portland was the venue for a double wedding in 1894. Theo Billeter married Elise Joss of Bethany, and William Graf of Bethany married Mathilde Billeter. Theo and Matilde were brother and sister. The Scheel house is where the First German Baptist Church of Portland was organized. The church is now located in southeast Portland and is known as Trinity Fellowship. The church was a daughter church of the German Baptist Church of Bethany. The Theo Billeters are front and center, next to them is the minister. To his right are the William Grafs. (Courtesy Doug and Bernietta Graf.)

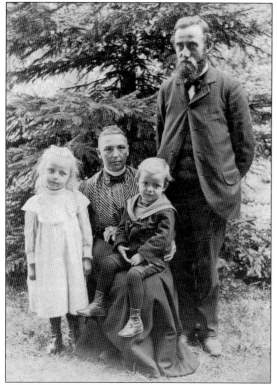

William Graf, his wife, Matilde, daughter, Martha, and young son, Paul (their only child who grew into adulthood), are seen in this c. 1902 photograph. William assisted the church of his father, Johann, in Cedar Mill for many years. In 1900, de joined Bethany Baptist Church, where he occasionally served as interim pastor. Martha, who prayed like an adult, and an infant son contracted diphtheria and passed away two months apart in 1906. Soon after, William felt led to become a full time minister. He served at a church in Washington before serving Bethany Baptist from 1913 until his death in 1934. (Author's collection.)

The view in this c. 1934 photograph looks south from the Peter Trachsel farm on NW Brugger Road to Springville Road. It shows the farm buildings and the parsonage of Bethany Presbyterian Church on the left side. On the right is the Stalder farmhouse. The Stalder family emigrated from Switzerland to the United States in 1876. (Courtesy Gene and Launa Zurbrugg.)

Samuel Boehi, who lived in the Bethany originally and later in Portland, married Margaret Stalder of Bethany in 1888. This photograph is from about 1890. Her parents, John and Marianna Stalder, and family emigrated from Switzerland to Bethany in 1876. They were part of the group of 71 Swiss who came to the United States under the leadership of Samuel Siegenthaler. They were charter members of the German Baptist Church of Portland, a daughter church of Bethany Baptist. (Courtesy Trinity Fellowship Church.)

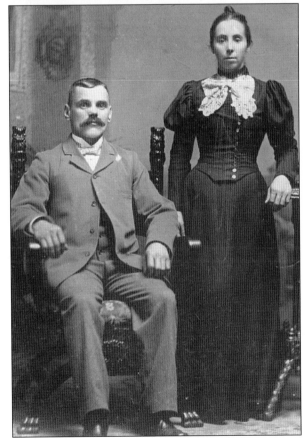

Sophia Hauswirth Bardsley poses with her three children from her first marriage, to Francis M. Bardsley. They had married in Missouri in 1885 and came to Oregon later. Francis worked at Bridal Veil Lumber Company. In 1891, he died without having a will. She was named executrix. From left to right are Sophia and her daughters—Elva, Lena, and Grace. (Courtesy Ray and Beverly Kestek.)

Abraham "Abe" Zahler came to Oregon from Frutigen, Switzerland, with his mother and siblings around 1890. He married Sophia Bardsley in 1895. The Zahlers lived on a farm in Multnomah County on NW Springville Road, east of the Washington-Multnomah county line. She had owned the property before their marriage and sold it to Zahler. Their children were Walter, Abe Jr., Alfred "Fred," and Frieda. Sophia died of consumption in 1905; Abe never remarried. (Courtesy Gene and Launa Zurbrugg.)

Abe Zahler built this barn in 1914. He was assisted by his sons—Fred "Fritz," Walter, and Abraham "Abe" Jr. This photograph is from 1918. The barn stood until it was dismantled by Robert "Bob" Zahler in 1982. (Courtesy Ray and Beverly Kestek.)

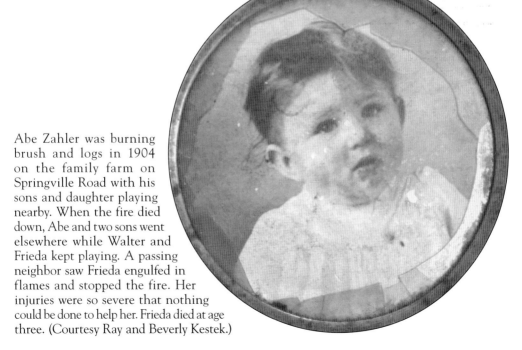

Abe Zahler was burning brush and logs in 1904 on the family farm on Springville Road with his sons and daughter playing nearby. When the fire died down, Abe and two sons went elsewhere while Walter and Frieda kept playing. A passing neighbor saw Frieda engulfed in flames and stopped the fire. Her injuries were so severe that nothing could be done to help her. Frieda died at age three. (Courtesy Ray and Beverly Kestek.)

97

Hope Luchs sits on the porch of the rustic house on NW Springville Road, which was on the property she and her husband William "Skinny" Luchs purchased in the mid-1950s. They later remodeled it by updating the siding and adding a back porch, which included a bathroom with indoor plumbing. They had five children in the house before building a ranch home with a daylight basement next door in the early 1960s. (Courtesy Patty Luchs Nelson.)

Photographed in 1979, this house on NW Springville Road was home to a moonshiner named Zillmer during Prohibition and for many years after that. It has been said that he had a still in his house and had a still beyond the house—surrounded by and protected by dynamite. (Author's photograph.)

This Spanish-style house was home to Frank and Louise Miller on NW Springville Road. She was a half sister to Gaza Burger. This image is from the 1930s. (Courtesy Dale Burger.)

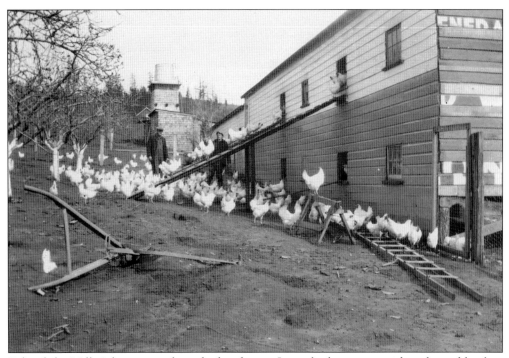

Behind the Miller's house was their chicken house. It was built, in part, with reclaimed lumber. Some of the siding boards have words and letters on them. (Courtesy Dale Burger.)

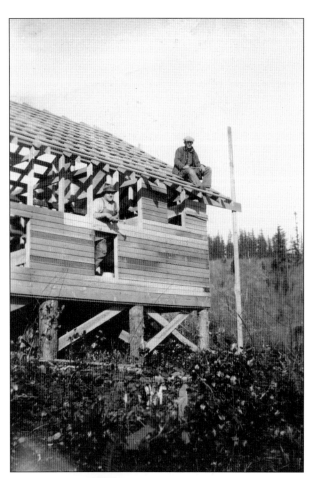

Gaza Burger, in the window, and Fred Pfister, on the roof, are in this photograph of the construction of Burger's chicken house on the Multnomah County side of Springville Road. It dates to March 1935. Pfister's farm was on Kaiser Road north of Springville. (Courtesy Dale Burger.)

This image from the 1920s shows cordwood on NW Springville Road. Longtime resident Benny Gerber used to tell stories about trees being cut for firewood. Drivers from Portland's Albina Fuel Company came to pick up the wood in chain-driven trucks with hard rubber tires. (Courtesy Dale Burger.)

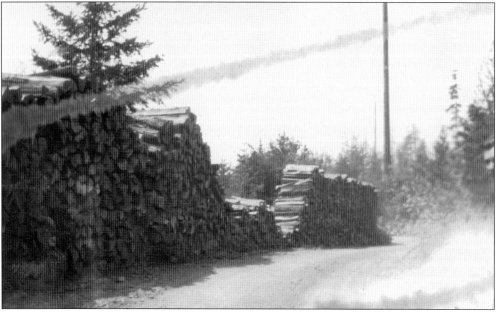

Abraham "Abe" Zurbrugg, originally from Switzerland, married Susannah Zahler in 1895. Around 1890, Susannah had immigrated to the United States with her mother, three other siblings, and her brother Abe Zahler, who later lived on Springville Road. The Zurbruggs had four children—Edwin, Elmer, Otto, and Hulda. They had a dairy farm on NW Old Germantown Road. (Courtesy Gene and Launa Zurbrugg.)

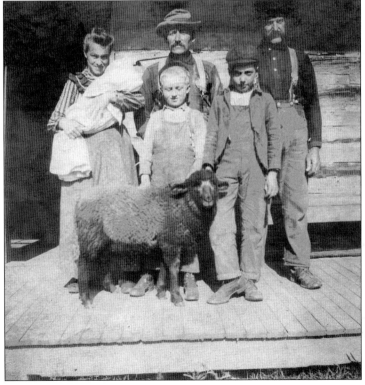

The Abraham Zurbrugg family is shown on the porch on their log house in 1906. They are, from left to right, (first row) Elmer and Edwin; (second row) Susannah holding infant Otto, her husband, Abraham, and his brother Chris. (Courtesy Gene and Launa Zurbrugg.)

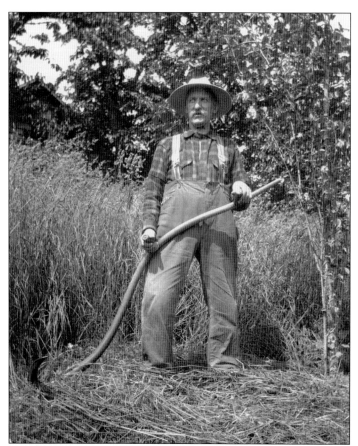

Farmer Chris Zurbrugg and brother Abe came to America from Switzerland about 1880. They lived in the Midwest on a dairy that made cheese. In the mid-1880s, the Zurbrugg brothers moved to Oregon and bought property on Old Germantown Road, northeast of Bethany. They operated a dairy farm. In this 1926 photograph, Chris leans on a scythe, an implement used to cut crops on sloping ground. (Courtesy Gene and Launa Zurbrugg.)

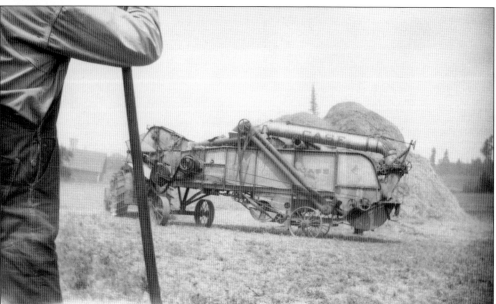

One of the Zurbrugg brothers watches the Case threshing machine on the Zurbrugg farm. The photograph dates to the mid-1920s. (Courtesy Gene and Launa Zurbrugg.)

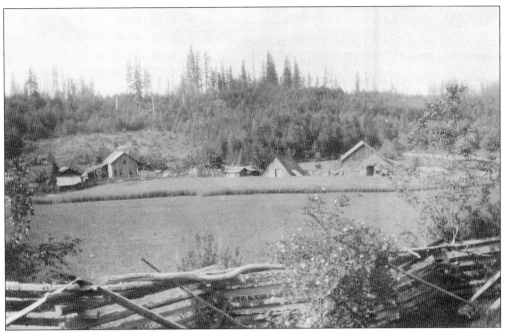

This is a pre-1922 view of the Zurbrugg farm. (Courtesy Gene and Launa Zurbrugg.)

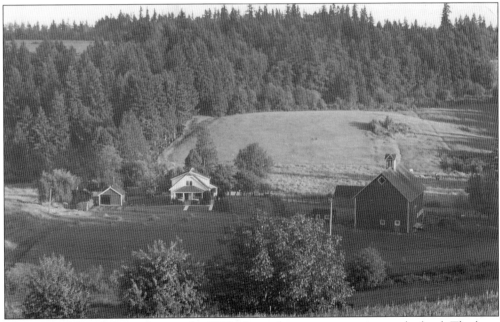

This view of the Zurbrugg farm in the 1930s shows the newer structures on the land. The barn on the right was built in 1922. The house at left center was built around 1925. (Courtesy Gene and Launa Zurbrugg.)

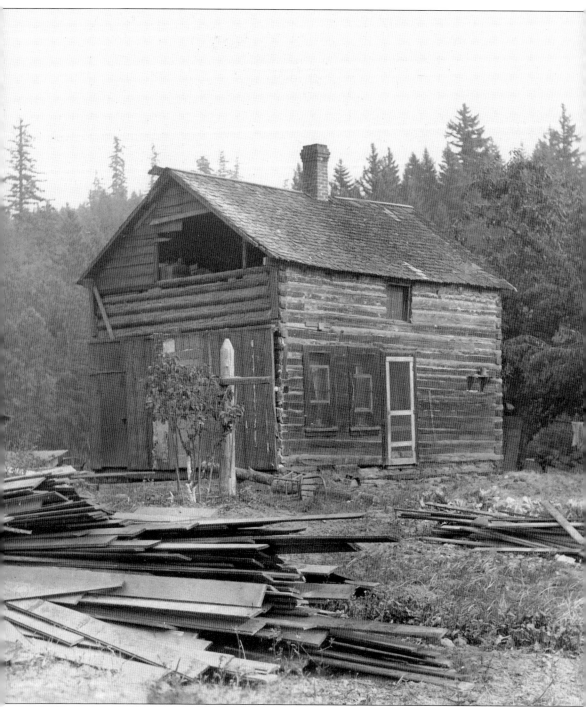

This is the original Zurbrugg log house in 1933 before it was moved. (Courtesy Gene and Launa Zurbrugg.)

Paul and Anna Huserik were married in the Austro-Hungarian area of Europe that later became Czechoslovakia. He came to Oregon in 1906; his wife joined him a year or two later. Their farm was on NW Old Germantown Road. The view of their house is from the mid-1940s. The family included eight boys and two girls. The previous owners of the farm were Christian Linder and his wife, who came to the area in 1872. (Both, courtesy Gene and Launa Zurbrugg.)

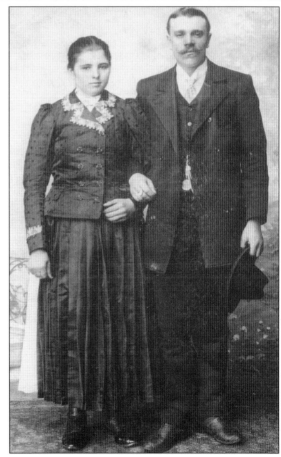

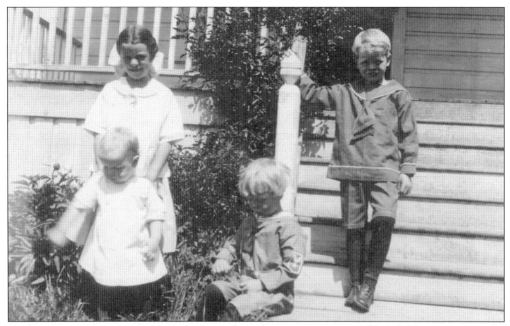

In this c. 1923 photograph, Ferdinand "Ferd" and Mary "Mayme" Toelle's children stand on the porch of their house, which was north of the Huseriks' on the Jack Sharpe place. Standing to the left are Verna and Ralph, to the right is Bob, and Marshall is seated on the lower step. In 1928, the Toelle house burned down. The neighbors on the hill above their house came to help save what they could. According to Marshall Toelle, "They saved almost everything including the player piano." Some of the older Huserik boys carried the old player piano down the steps and rescued it. (Courtesy Alan Toelle.)

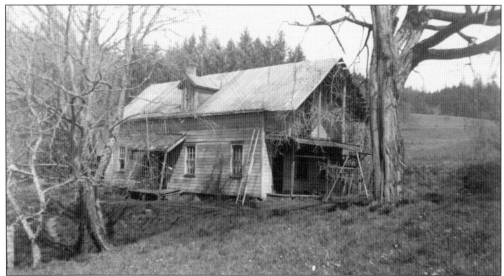

The Claude Reed place was east of Toelles' above NW Germanton Road. The image of the house is from 1952; it was built in the 1870s. The deed was signed by Pres. Rutherford B. Hayes. According to Alan Toelle, who lived in the house his junior and senior year of high school, the front two-thirds of the structure was a log cabin with siding attached. The walls were approximately 18 inches thick at the windows and doors. (Courtesy Alan Toelle.)

Francis (Frank) Reichen sits in a wagon pulled by his dog at his family's farm near the intersection of NW Germantown and Cornelius Pass Roads. The photograph dates to 1923. (Courtesy Reichen family.)

Chris Reichen and his grandson Roy pose on the 1936 Chevrolet fire tanker truck near the Reichen residence on NW Germantown and Cornelius Pass Roads. The truck was loaned by the Cedar Mill Fire Department for use in the farming community northwest of Bethany near the intersection of NW Germantown Road. The truck was parked in a garage on Reichen's property. (Courtesy Reichen family.)

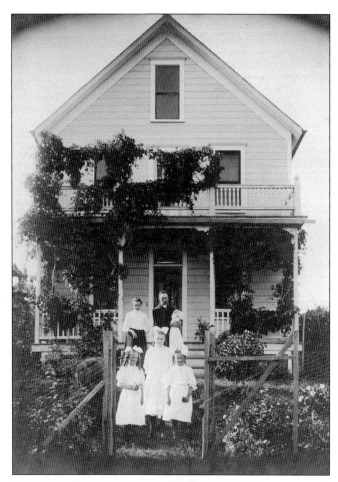

Walter Wismer, his wife, and children lived on a farm on NW Cornelius Pass Road beginning in the late 1890s. The farm was purchased for him by his father, Jacob Wismer of Bethany, who bought farms for his sons when they married. The family is shown in this 1909 photograph. (Author's collection.)

This house is said to have been built by E.I. Kuratli before 1900. It was later the Staehle farm before the Frank Reichen family purchased it in 1949. The house is decorated for the Fourth of July in 2017. (Author's photograph.)

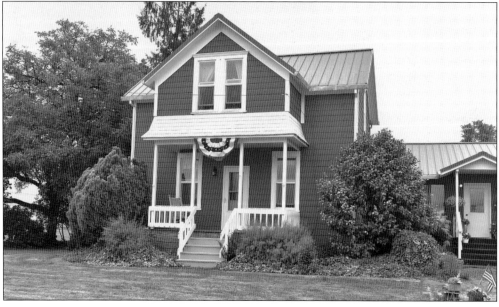

Seven

PHILLIPS AND HELVETIA

Phillips had a store with a post office across from the Pezoldt farm. The community was named in honor of Phillip Pezoldt; it is also known as Rock Creek. There was a dance hall on the second floor where neighborhood musicians played for events. The post office opened in 1895; Charles O. Hansen was the first postmaster. In 1896, the store was owned by Fred Toelle; who was then postmaster. The post office closed in 1904 when rural free delivery of mail was instituted in the area. The store fixtures and goods were offered for sale in 1907. Later, in addition to farming, Toelle would deliver goods in his 1915 truck to Portland for area farmers. This view was photographed in 1979. The building has been gone for many years. The area also was home to a sawmill, a church, a blacksmith shop, and a school. (Author's photograph.)

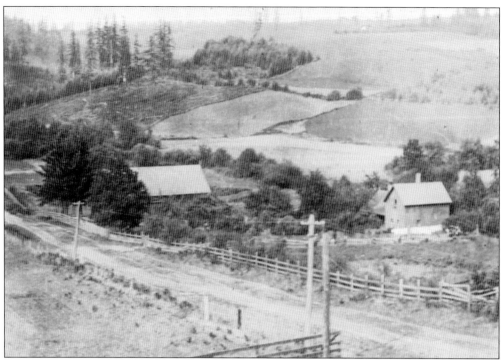

This c. 1914 photograph shows the Phillips community crossroads of NW Phillips and Old Cornelius Pass Roads. (Huserik-Fuegy collection.)

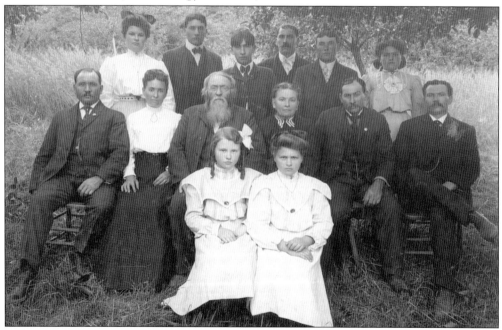

In the early 1900s, the Ulrich Fuegy family was photographed on their farm in the Rock Creek-Phillips area. Pictured from left to right are (first row) Emma and Lelah; (second row) John, Christina, Ulrich (father), Louisa (mother), Adolph, and Bob; (third row) Anna, Ted, Henry, Bill, Ed, and Lizzie. Daughter Mary is not in the photograph because she had scarlet fever. (Courtesy Clark and Betty Dysle.)

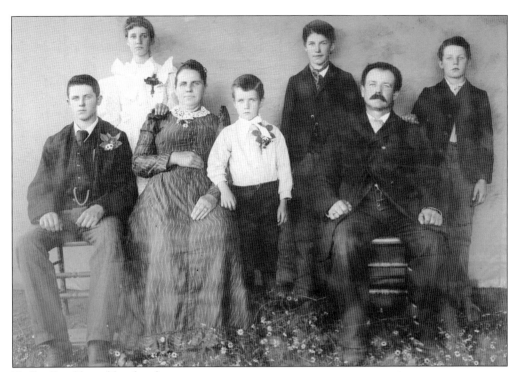

Phillip Pezoldt and his family came to the Rock Creek area in the 1880s. He was born in Germany and married Martha Smekel in Missouri in 1875; they later lived in Colorado before arriving in Oregon. The family posed for this photograph in early 1895. They are, from left to right, (first row) Edward, Rose, Martha (mother), Phillip Jr., and Phillips Sr. (father); (second row) Frank and Louie. Daughter Myrtle was born in November 1895. (Courtesy Huserik-Fuegy Collection.)

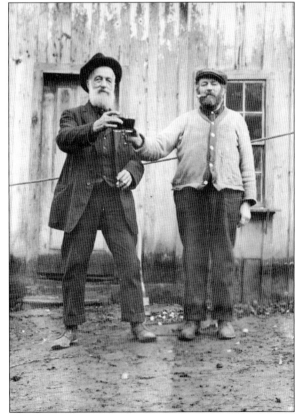

In this c. 1913 photograph, Phillip Pezoldt, on the right, is seen with his neighbor and friend John J. Kuratli enjoying a glass of wine. Kuratli, who came to the area from New York in the mid-1870s, had a farm at NW Cornelius Pass and Germantown Roads. Pezoldt's daughter Myrtle married blacksmith William Fuegy in 1913. (Courtesy Huserik-Fuegy Collection.)

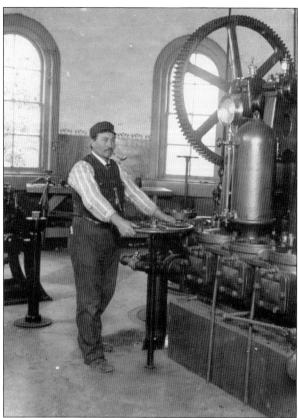

Adolph Fuegy was the first blacksmith in the shop that he built on Old Cornelius Pass Road in January 1896. His brother William "Bill" joined him in operating the shop. After Bill left the Rock Creek area in the early 1900s, Adolph worked for the Enterprise Brewing Company before securing a position at the Portland Water Bureau around 1904. Lorraine Schiebel remembers when she was a child in the 1930s and her family visited her Uncle Adolph and his family; she held her Uncle Adolph's hand as they walked while he made his rounds patrolling around Mount Tabor Reservoirs. (Author's collection.)

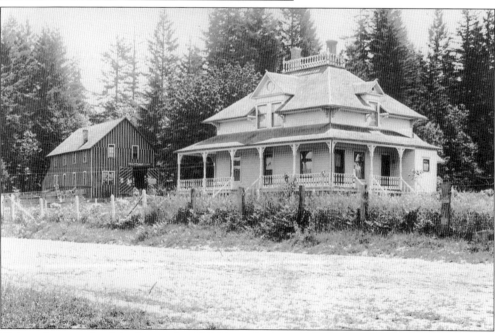

This a photograph of the house that Bill Fuegy built in 1913 for his wife, Myrtle Pezoldt. His Phillips Blacksmith Shop is in the background. (Courtesy Huserik-Fuegy Collection.)

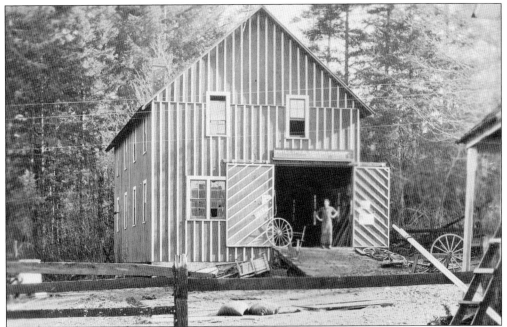

Bill Fuegy is seen in front of his blacksmith shop in this c. 1914 photograph. He operated the shop for many years. Later, he was badly burned at the shop and quit working as a blacksmith. He and his wife then operated the Rock Creek Store. The store burned down in 1941. (Courtesy Huserik-Fuegy Collection.)

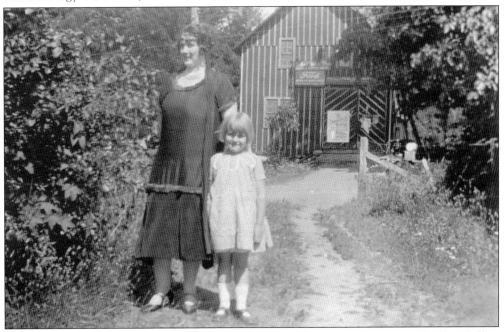

Myrtle Fuegy and her daughter June are in the foreground of this 1924 photograph. The Phillips blacksmith shop is in the background. Bill Fuegy also repaired automobiles; signage on the building designates his establishment as providing authorized Ford service. (Courtesy Huserik-Fuegy Collection.)

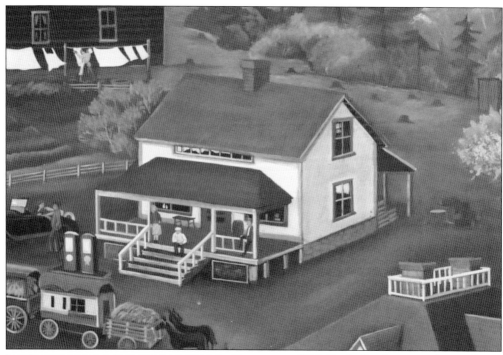

This Rock Creek store is depicted in a 1920s-era painting by McMenamins Pubs artist Jennifer Joyce. June Huserik (daughter of Bill Fuegy) recalled that an old couple lived in the house on the present site of Rock Creek Tavern and were the ones who opened the original business, which she referred to as "a little country store." Fuegy and his wife later ran the store. The store burned down in 1941 under unknown circumstances. (Author's photograph from detail of Jennifer Joyce painting in Rock Creek Tavern.)

After the fire, Bill Fuegy moved his blacksmith shop north and rebuilt it into the Rock Creek store. This view was photographed by Otto Zurbrugg from NW Cornelius Pass Road in 1943 and shows the Rock Creek Store. It became Rock Creek Tavern in 1973. It was acquired by the McMenamin brothers, Mike and Brian, in 1995. The structure burned down in 2002 but was rebuilt with salvaged barn board and other materials. (Courtesy Gene and Launa Zurbrugg.)

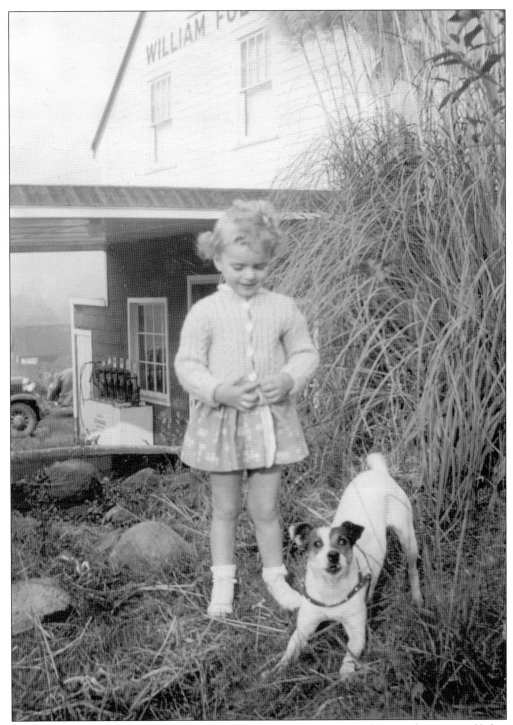

Sandy Huserik is standing with her grandfather's dog in this mid-1940s photograph. Her grandfather William "Bill" Fuegy's store is in the background. There are gasoline pumps in front. In the background, to the left of Sandy, a variety of automobile oil products are displayed. (Courtesy Huserik-Fuegy Collection.)

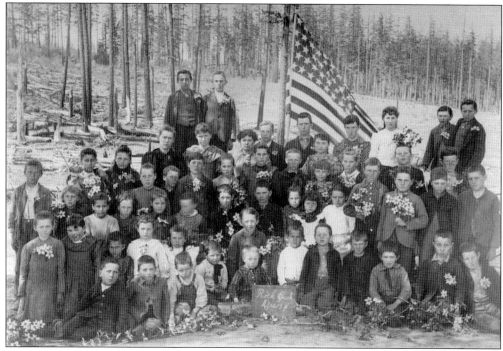

The Rock Creek School was built in the late 1880s on NW Phillips Road near Old Cornelius Pass. This patriotic-themed image with the United States flag is an 1894 or 1895 view of the students of Rock Creek School District No. 54. There are some Toelle and Luethe children in the group. (Courtesy Alan Toelle.)

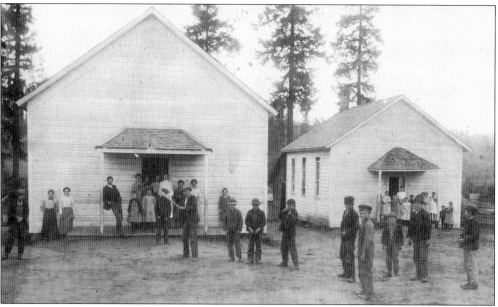

There was such an overabundance of children that another building was constructed to the right of the original one around 1895 to accommodate all the students. This photograph is from 1905. Children can be seen playing baseball. These buildings were replaced was a new larger structure in 1912 or 1913. (Courtesy Reichen family.)

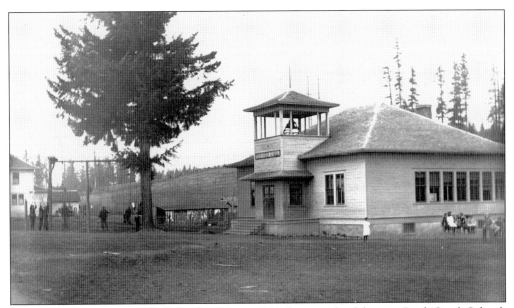

Children are on swings in the left side of the c. 1914 photograph of the new Rock Creek School, which served the community until the mid-1940s. The Gutschmidt house can be seen beyond the swings farther to the left. (Courtesy Jean Hoffelner.)

Rock Creek School students, from the Fuegy family that lived off of Phillips Road between NW Dick Road and Valley Vista, pose with their lunch baskets before their walk to school. (Courtesy Clark and Betty Dysle.)

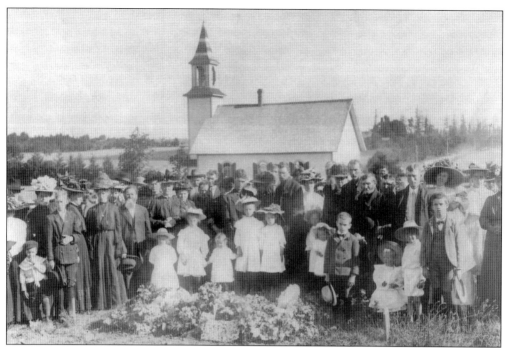

The Phillips Reformed Church congregation poses around a grave in the church cemetery. Their building is in the left background in this early-1900s photograph; the church burned down in 1938 as a result of arson. Brooks Luethe, who delivered newspapers in the area, was out collecting one evening and saw an automobile parked outside with its lights on. He thought someone was there for a meeting. When he got home in the Skyline area, he saw a glow in the sky back toward the church. He came back and smelled gasoline as he saw the church burn. The congregation merged with the Helvetia church. The view in this modern photograph from 2017 looks across the cemetery to the former church site. (Above, courtesy Wayne and Barbara Hess; below, author's collection.)

John Schneider and his family, also of Phillips, pose for a studio portrait around 1909. Pictured from left to right are (first row) Emma, Gottlieb, and Carl; (second row) Ida, Christina (mother), and Anna; (third row) John W. Schneider Sr. (father), Cecilia, and John W. Jr. In 1910, children Cecelia, Ida, and Carl contracted diphtheria. They all passed away within a three-week period. Christina was the daughter of Ulrich and Louisa Fuegy. (Courtesy Lorraine Schiebel.)

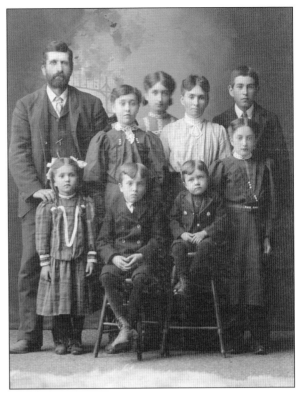

John Gutschmidt of Phillips, a farmer, was a peddler of farm products. He is seen on his wagon in this c. 1910 photograph. Gutschmidt went to various farms in the area to buy goods to sell to the wealthy residents of northwest Portland. He is said to have also bought furniture from a Portland customer that fell on hard times. (Courtesy Lorraine Schiebel.)

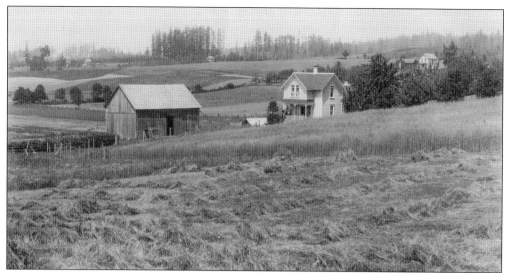

Carl and Ernestine Koesterke (later shortened to Kestek) came to the Phillips area in the mid-1890s. They immigrated to the United States from Russia. Their 20-acre farm was on NW 195th Avenue, north of NW Phillips Road. Their children were William, Hulda, Hanna, Henry, and Herman. The property remained in the family into the 1950s. (Courtesy Ray and Beverly Kestek.)

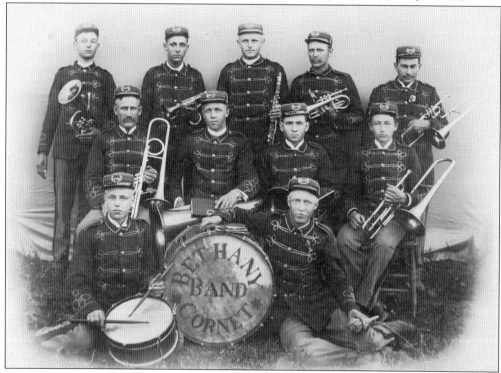

The Bethany Band of Phillips was organized in 1893. Band members in 1895 are, from left to right, (first row) Ferdinand Toelle and Bill Toelle; (second row) Charles Hansen, John C. Toelle, John Fuegy, and Edward Frantz; (third row) Sam Kuratli, H.A. Kuratli, Hermann Toelle, unidentified, and Adolph Fuegy. Over the years, the band included Wismer family members from the Bethany area as well as Theo Rich from Orenco. (Courtesy Alan Toelle.)

Bill Fuegy, a Phillips blacksmith, was a bicycle racer in the late 1890s and early 1900s. In this portrait, he is wearing a medal for winning a four-mile race in July 1900, sponsored by the Native Sons of Oregon. (Courtesy Huserik-Fuegy Collection.)

This c. 1918 photograph was probably taken in Phillips and includes Herman Kestek, Myrtle Fuegy, her father Bill, Albert "Dutch" Toelle and his wife, Elizabeth "Lizzie" Toelle. Fuegy's friend Dutch Toelle was an avid bicyclist who won a bicycle race at Portland's Mount Tabor in 1905. (Courtesy Huserik-Fuegy Collection.)

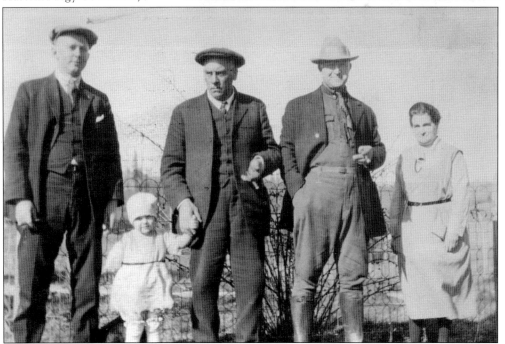

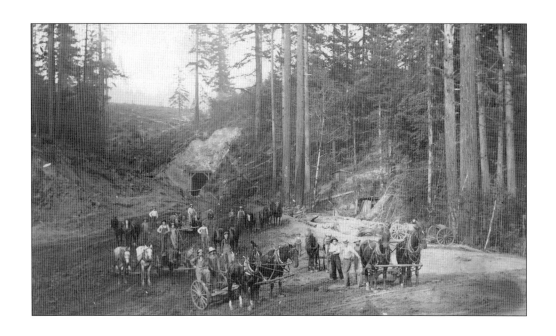

Known today as the Cornelius Pass Tunnel, a railroad tunnel for the United Railway Company's electric railroad is under construction around 1909 (above). Lorraine Schiebel's father, John Schneider, was one of the tunnel workers. A 2017 photograph (below) shows a Portland and Western train emerging from the tunnel. (Above, author's collection; below, courtesy Randy Nelson.)

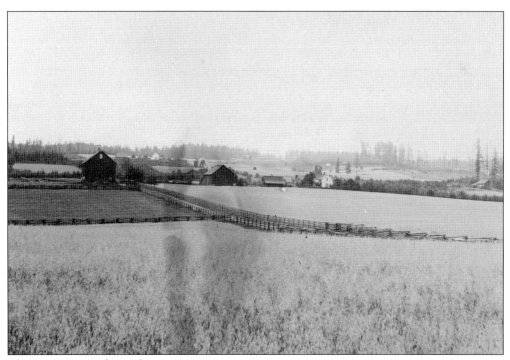

This c. 1910 view shows the Josses' farm was in Helvetia at the end of NW Groveland Road near Dierdorf Road. The white house at the top center of the photograph is the Yungen House on NW Helvetia Road. (Courtesy Gene and Launa Zurbrugg.)

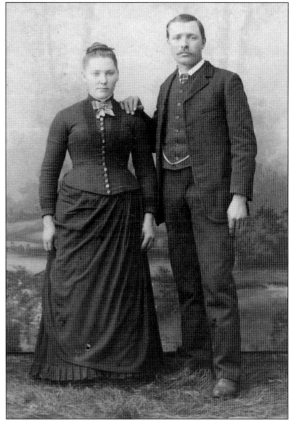

William and Sophia Josse were married on December 31, 1887, at the German Presbyterian Church of Bethany. Both were from Swiss immigrant families who had settled in the United States, moving to Oregon in the 1880s. Sophia's brothers, Chris and Abraham, had a farm on Old Germantown Road near Bethany. This c. 1891 portrait of the Josses was taken by Hillsboro photographer A.B. Crandall. (Author's collection.)

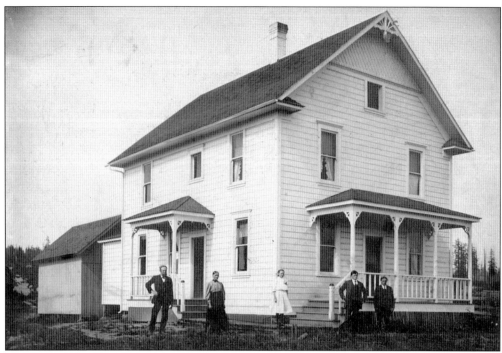

This is a c. 1912 photograph of the Abraham Yungen house and family in Helvetia on NW Helvetia Road. In earlier days, their last name was spelled Jungen. (Courtesy Bob and Beverly Yungen.)

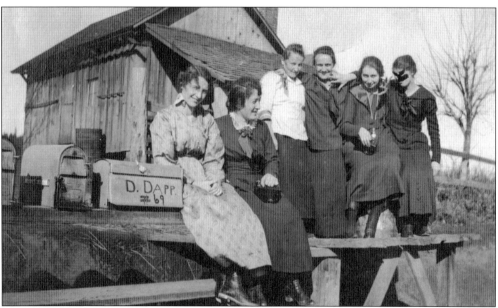

Six girls sit on the Yungen farm fence. The Dapp mailbox is for the farm across the road to the south. In the background is the Yungen cheese shed, which was built by Helvetia carpenter Fred Bishop around 1900. It would blow down during the Columbus Day storm of 1962, but the floor remained. A cow fell through the floor at a later date; it was successfully rescued. The photograph dates to the mid-1910s. (Courtesy Lorraine Schiebel.)

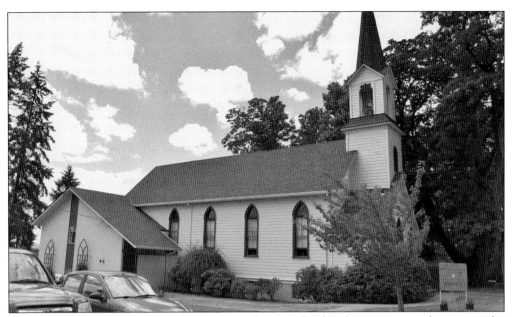

The Helvetia Community Church was originally part of a church organization that met in the homes of members in Helvetia, Phillips, and West Union in 1881. It was named the Emmanuel Reformed Church. Eventually, churches were erected only in Phillips and Helvetia. The Phillips congregation was absorbed into the Helvetia Church after their building burned down in 1938. With denominational changes, the church became known as Helvetia Community Church. In addition to tending to the spiritual needs of the community, the church hosts a Swiss Festival after a church service in the summer. (Author's photograph.)

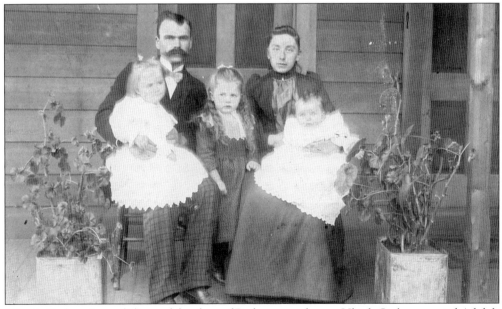

Minnie Gerber, sister of Elise and daughter of Bethany storekeeper Ulrich Gerber, married Adolph Badertscher of Helvetia in 1896. Both of their families came to Oregon in the mid-1870s. Adolph and Minnie's first five children were girls; then they had five boys. They pose with their daughters Hedwig, Anna, and Bertha. The photograph is from about 1900. (Author's collection.)

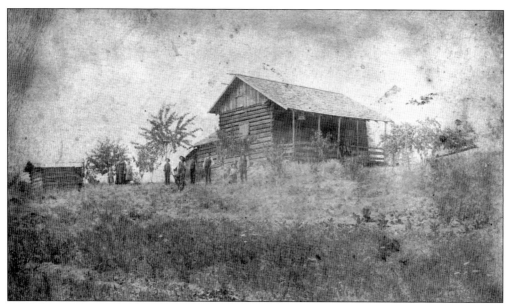

Adolph Siegrist, a traveling photographer based in Cedar Mill, photographed the Joseph Bishop family on their farm in the late 1880s or early 1891. Their log cabin is in the right background. The family name was originally spelled Bischoff. They were from Germany and settled in 1872 in Helvetia. (Author's collection.)

In 1979, Don and Nancy Miller bought part of the old Wenger property on NW Bishop Road. The house was originally a two-room shack that was moved to their property in the early 1930s. The old house was run-down. Bethany carpenter Dave Turple told them that "the structure is fine. You could remodel it." He worked on some of the remodeling projects. The photograph is from about 1980. Today, the Helvetia Lavender Festival is held at the Helvetia Lavender Farm that the Millers started several years ago. (Courtesy Don and Nancy Miller.)

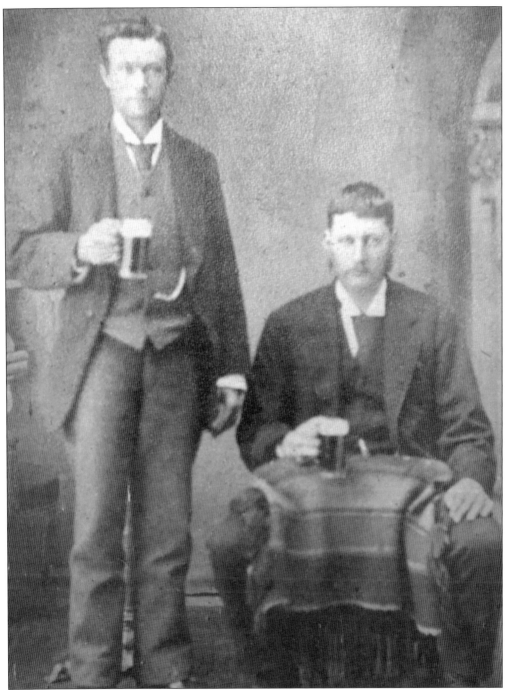

Alfred Guerber lifts a mug of beer with his friend Peter Welty. Guerber came to work at the farm of his future father-in-law, Samuel Siegenthaler, in Cedar Mill. There, he met his future wife, Rossette, whom he married in the early 1880s. The Guerbers settled in Helvetia. Welty, a carpenter in Helvetia built the Guerbers a four-room house, which he later enlarged to a two-story house; he also lived with the family. A 1917 article in the *Hillsboro Argus* notes that Welty had built more structures than anyone else in the northeast of the county. (Courtesy Don Guerber.)

DISCOVER THOUSANDS OF LOCAL HISTORY BOOKS
FEATURING MILLIONS OF VINTAGE IMAGES

Arcadia Publishing, the leading local history publisher in the United States, is committed to making history accessible and meaningful through publishing books that celebrate and preserve the heritage of America's people and places.

Find more books like this at
www.arcadiapublishing.com

Search for your hometown history, your old stomping grounds, and even your favorite sports team.

Consistent with our mission to preserve history on a local level, this book was printed in South Carolina on American-made paper and manufactured entirely in the United States. Products carrying the accredited Forest Stewardship Council (FSC) label are printed on 100 percent FSC-certified paper.

MADE IN THE
USA